This is a history of intellectual courage, hard work, occasional inspiration and every conceivable form of human failing. It is also an extended invitation to wonder, to pleasure

1 3 5 7 9 10 8 6 4 2

Vintage
20 Vauxhall Bridge Road,
London SW1V 2SA

Vintage Classics is part of the Penguin Random House
group of companies whose addresses can be found at
global.penguinrandomhouse.com

Penguin
Random House
UK

Ian McEwan is an unlimited company registered in
England and Wales no. 7473219

Solar was first published in Great Britain by Jonathan Cape in 2010,
Enduring Love was first published in Great Britain by Jonathan Cape in 1997,
Machines Like Me was first published in Great Britain by Jonathan Cape in
2019

This edition published by Vintage in 2019

penguin.co.uk/vintage

A CIP catalogue record for this book is available from the British Library

ISBN 9781784875688

Typeset in 10.5/14.5 pt FreightText Pro
by Jouve (UK), Milton Keynes
Printed and bound in Great Britain by Clays Ltd, Elcograf S.p.A.

Penguin Random House is committed to a sustainable future for our
business, our readers and our planet. This book is made from Forest
Stewardship Council® certified paper.

MIX
Paper from
responsible sources
FSC
www.fsc.org FSC® C018179

Science

IAN McEWAN

VINTAGE MINIS

Contents

1. Literature, Science and Human Nature 1
2. The Originality of the Species 33
3. A Parallel Tradition 54
4. End of the World Blues 66
5. Solar 99
6. Enduring Love 109
7. Machines Like Me 111

1

Literature, Science and Human Nature

GREATNESS IN LITERATURE is more intelligible and amenable to most of us than greatness in science. All of us have an idea, our own, or one that has been imposed upon us, of what is meant by a great novelist. Whether it is in a spirit of awe and delight, duty or scepticism, we grasp at first hand, when we read *Anna Karenina*, or *Madame Bovary*, what people mean when they speak of greatness. We have the privilege of unmediated contact. From the first sentence, we come into a presence, and we can see for ourselves the quality of a particular mind; in a matter of minutes we may read the fruits of a long forgotten afternoon, an afternoon's work done in isolation, a hundred and fifty years ago. And what was once an unfolding personal secret, is now ours. Imaginary people appear before us, their historical

and domestic circumstances are very particular, their characters equally so. We witness and judge the skill with which they are conjured.

By an unspoken agreement, a kind of contract between writer and reader, it is assumed that however strange these people are, we will understand them readily enough to be able to appreciate their strangeness. To do this, we must bring our own general understanding of what it means to be a person. We have, in the terms of cognitive psychology, a theory of mind, a more or less automatic understanding of what it means to be someone else. Without this understanding, as the psychopathology shows, we would find it virtually impossible to form and sustain relationships, read expressions or intentions, or perceive how we ourselves are understood. To the particular instances that are presented to us in a novel, we bring this deep and broad understanding. When Saul Bellow's Herzog stands in front of a mirror, as characters in fiction so often and conveniently do, he is wearing only a newly purchased straw hat and underpants. His mother

wanted him to become a rabbi, and he seemed to himself gruesomely unlike a rabbi now in the trunks and straw hat, his face charged with heavy sadness, foolish utter longing of which a religious life might have purged him. That mouth! – heavy

with desire and irreconcilable anger, the straight nose sometimes grim, the dark eyes! And his figure! – the long veins winding in the arms and filling in the hanging hands, an ancient system, of greater antiquity than the Jews themselves . . . Bare-legged, he looked like a Hindu.

A reader may not understand from the inside every specific of Herzog's condition – a mid-twentieth-century American, a Jew, a city dweller, a divorcé, an alienated intellectual, and nor might a young reader sympathise with the remorse of early middle age, but self-scrutiny that is edging towards a reckoning has a general currency, as does the droll, *faux naïf* perception that one's biology – the circulatory system – predates and, by implication, is even more of the essence of being human, than one's religion. Literature flourishes along the channels of this unspoken agreement between writers and readers, offering a mental map whose north and south are the specific and the general. At its best, literature is universal, illuminating human nature at precisely the point at which it is most parochial and specific.

Greatness in science is harder for most of us to grasp. We can make a list of scientists we've been told are great, but few of us have had the kind of intimate contact that would illuminate the particular

qualities of any particular achievement. Partly, it's the work itself: it doesn't invite us in – it's objectifying, therefore distancing, corrupted by difficult or seemingly irrelevant detail. Mathematics is also a barrier. Furthermore, scientific ideas happily float free of their creators. Scientists might know the classical Laws of Motion but have never read Newton on the matter, or have grasped relativity from text books without reading Einstein's Special or General Theories, or know the structure of DNA without having – or needing – a first-hand knowledge of Crick and Watson's 1953 paper.

Here is a rare case in point. Their 1953 paper, a mere twelve hundred words, published in the journal *Nature*, ended with the famously modest conclusion: 'It has not escaped our notice that the specific pairing we have postulated immediately suggests a possible copying mechanism for the genetic material.' 'It has not escaped our notice . . .': the drawing-room politesse of the double negative is touchingly transparent. It roughly translates as, 'Look at us, everybody! We've found the mechanism by which life on earth replicates, we're excited as hell and can't sleep a wink.' 'It has not escaped our notice' is the kind of close contact I mean. In a scientific paper it is not often encountered at first hand.

However, there is one pre-eminent scientist who is almost as approachable in this respect as a

novelist. It's perfectly possible for the non-scientist to understand what it is in Darwin's work which makes him unique and great. In part, it is the sequence of benign accidents that set him on his course, each step to be measured against the final achievement. And partly it's the subject itself. Natural history, or nineteenth-century biology generally, was a descriptive science. The theory of natural selection is not, in its essentials, difficult to understand, though its implications have been vast, its applications formidable and its elaborations in scientific terms quite complex – as the computational biology of William Hamilton shows. Partly, too, because Darwin, though not the greatest prose writer of the nineteenth century, was intensely communicative, affectionate, intimate and honest. He wrote many letters, and filled many notebooks.

Let us read his life as a novel, like Herzog, driving forwards towards a great reckoning. The sixteen-year-old Charles is at university in Edinburgh and beginning to show disillusionment with the study of medicine. He writes to his sisters that 'I am going to learn to stuff birds, from a blackamoor.' Charles takes his lessons in taxidermy from one John Edmonstone, a freed slave, and found his teacher 'very pleasant and intelligent'. Edmonstone recounts to the young Darwin his experiences as a slave, and describes the wonders of a tropical rainforest. All his

life, Darwin was to abhor slavery, and this early acquaintanceship may have had some bearing on the relatively neglected book of Darwin's I want to discuss. The following year Darwin comes in contact with the evolutionary ideas of Lamarck, and in the Edinburgh debating societies hears passionate, godless arguments for scientific materialism. He spends days foraging along the shores of the Firth of Forth looking for sea creatures, and an 1827 notebook records detailed observations of two marine invertebrates.

Since Charles does not warm to the prospect of becoming a physician, his father 'proposed that I should become a clergyman. He was very properly vehement against my turning an idle sporting man, which then seemed my probable destination.' So he studies at Cambridge where, at the age of eighteen, his love of natural history is becoming a passion. 'What fun we will have together,' he writes to his cousin, 'what beetles we will catch, it will do my heart good to go once more together to some of our old haunts . . . we will make regular campaigns into the Fens; Heaven protect the beetles.' And in another letter, 'I am dying by inches from not having anybody to talk to about insects.' In his last two terms, his mentor Henslowe, Professor of Botany, persuades him to take up geology.

After Cambridge, the offer comes through Henslow

to be the naturalist and companion to the captain on board the *Beagle*, making a government survey of South America. We may follow the wrangling as he persuades his father, with the help of Uncle Josiah Wedgewood. 'I must state again,' implores the earnest Charles, 'I cannot think it would unfit me hereafter for a steady life.' Many weeks of delay, then, after two false starts, he sets sail on 27 December 1831. Days of seasickness, then the *Beagle* is prevented by quarantine measures from landing in La Palma in the Canaries. But Charles has a net in the stern of the ship, the weather is fine and he catches 'a great number of curious animals, and fully occupied my time in my cabin'. Finally, landfall at St Jago in the Cape Verde islands, and the young man is in ecstasy. 'The island has given me so much instruction and delight,' he writes to his father; 'it is utterly useless to say anything about the scenery – it would be as profitable to explain to a blind man colours, as to person who has not been out of Europe, the total dissimilarity of a tropical view . . . Whenever I enjoy anything I always look forward to writing it down . . . So you must excuse raptures and those raptures badly expressed.'

He enjoys working in his cramped cabin, drawing and describing his specimens of rocks, plants and animals and preserving them to send them back to England, to Henslow. The enthusiasm does not die

as the expedition proceeds, but to it is added a grow-
ing scientific confidence. He writes to Henslowe,

> nothing has so much interested me as finding
> two species of elegantly coloured Planariae,
> inhabiting the dry forest! The false relation they
> bear to snails is the most extraordinary thing of
> the kind I have ever seen . . . some of the marine
> species possess an organisation so marvellous
> that I can scarcely credit my eyesight . . . Today I
> have been out and returned like Noah's Ark, with
> animals of all sorts . . . I have found a most curi-
> ous snail, and spiders, beetles, snakes, scorpions
> *ad libitum*. And to conclude, shot a Cavia weighing
> one hundredweight . . .

With vast quantities of his preserved specimens
preceding him, and already being described, and
with his own theories about the formation of the
earth, and of coral reefs, taking shape in his mind,
Darwin arrives back in England five years later, at
the age of twenty-seven, already a scientist of some
standing. There is something of the thrill and illumi-
nation of great literature when Darwin, at the age of
twenty nine, only two years after he had returned
from his voyage on the *Beagle*, and still twenty-one
years before he would publish *On the Origin of Species*,
confides to a pocket notebook the first hints of a

simple, beautiful idea: 'Origin of man now proved . . . He who understands baboon would do more towards metaphysics than Locke.'

And yet *On the Origin of Species* itself does not allow an easy route into an understanding of Darwin's greatness. Read as a book rather than as a theory, it can overwhelm the non-specialist reader with a proliferation of instances – the fruits of Darwin's delay – and it's significant that the most frequently quoted passages occur in the final paragraphs.

Darwin was the sort of scientist whose work permeated his life. His later study of the earthworms in the garden at Downe is well known. He attended country markets to quiz horse, dog and pig breeders, and at country shows he sought out growers of prize vegetables. Always a warmly devoted father, he recorded in a notebook, 'My first child was born on December 27th 1839, and I at once commenced to make notes on the first dawn of the various expressions which he exhibited . . .' Long before an innate theory of mind had been postulated, Darwin was experimenting with his eldest child, William, and reaching his own conclusions:

When [William was] a few days over six months old, his nurse pretended to cry, and I saw that his face instantly assumed a melancholy expression, with the corners of the mouth strongly depressed.

Therefore it seems to me that an innate feeling must have told him that the pretended crying of his nurse expressed grief; and this, through the instinct of sympathy, excited grief in him.

While out riding, he stops to talk to a woman, and notes the contraction in her brows as she looks up at him with the sun at his back. At home he takes three of his children out into the garden and gets them to look up at a bright portion of the sky. The reason? 'With all three, the orbicular, corrugator and pyramidal muscles were energetically contracted, through reflex action . . .'

Over many years, while engaged in other work, Darwin was researching *The Expression of the Emotions in Man and Animals*, his most extraordinary and approachable book, rich in observed detail and brilliant speculation, beautifully illustrated – one of the first scientific books to use photographs, including some of his own baby pouting and laughing – and available in a third edition, prepared and annotated by the American psychologist of the emotions, Paul Ekman. Darwin not only sets out to describe expressions in dogs and cats as well as man – how we contract the muscles around our eyes when we are angry and reveal our canine teeth, and how, in Ekman's words, we want to touch with our faces those we love; he also poses the difficult question,

Why? Why do we redden with embarrassment rather than go pale? Why do the inner corners of the brow lift in sorrow, and not the whole brow? Why do cats arch their backs in affection? An emotion, he argued, was a physiological state, a direct expression of physiological change. In pursuit of these questions, there are numerous pleasing digressions and observations: the way a billiard player, especially a novice, tries to guide the ball towards its target with a movement of the head, or even the whole body. How a cross child sitting on its parent's knee raises one shoulder and gives a backward push with it in an expression of rejection; the firm closure of the mouth during a delicate or difficult operation.

Behind this wealth of detail lay more basic questions. Do we *learn* to smile when we are happy, or is the smile innate? In other words, are expressions universal to all cultures and races, or are they culture-specific? He wrote to people in remote corners of the British Empire asking them to observe the expressions of the indigenous populations. In England he showed photographs of various expressions and asked people to comment on them. He drew on his own experience. The book is anecdotal, unscientific and very clear-sighted. The expressions of emotion are the products of evolution, Darwin concluded, and therefore universal. He opposed the influential views of the anatomist Sir Charles Bell

that certain unique muscles, with no equivalent in the animal kingdom, had been created by God in the faces of men to allow them to communicate their feelings to one another. In a footnote, Ekman quotes from Bell's book: 'the most remarkable muscle in the human face is the corrugator supercilii which knits the eyebrows with an enigmatic effect which unaccountably but irresistibly conveys the idea of mind.' In Darwin's copy of Bell's book, he has underlined the passage and written, 'I suspect he never dissected monkey.' Of course, these muscles, as Darwin showed, existed in other primates.

By showing that the same principles governing expression applied in primates and man, Darwin argued for continuity and gradation of species – important generally to his theory of evolution, and to disproving the Christian view that man was a special creation, set apart from all other animals. He was intent too on demonstrating, through universality, a common descent for all races of mankind. In this he opposed himself forcefully to the racist views of scientists like Agassiz, who argued that Africans were inferior to Europeans because they were descended from a different and inferior stock. In a letter to Hooker, Darwin mentions how Agassiz had been maintaining the doctrine of 'several species' (i.e. of man), 'much, I daresay, to the comfort of slave-holding Southerns'.

Modern palaeontology and molecular biology show Darwin to have been right, and Agassiz wrong: we are descended from a common stock of anatomically modern humans who migrated out of East Africa perhaps as recently as 200,000 years ago and spread around the world. Local differences in climate have produced variations in the species that are in many cases literally skin-deep. We have fetishised these differences to rationalise conquest and subjugation. As Darwin puts it:

all the chief expressions exhibited by man are the same throughout the world. This fact is interesting as it affords a new argument in favour of the several races being descended from a single parent stock, which must have been almost completely human in structure, and to a large extent, in mind, before the period at which the races diverged from each other.

We should be clear about what is implied by the universal expressions of emotion. The eating of a snail or a piece of cheddar cheese may give rise to delight in one culture and disgust in another. But disgust, regardless of the cause, has a universal expression. In Darwin's words: 'The mouth is opened widely, with the upper lip strongly retracted, which wrinkles the side of the nose.' The expression and the

physiology are products of evolution. But emotions are also, of course, shaped by culture. Our ways of managing our emotions, our attitudes to them, the way we describe them, are learned and differ from culture to culture. Still, behind the notion of a commonly held stock of emotion lies that of a universal human nature. And until fairly recently, and for a good part of the twentieth century, this has been a reviled notion. Darwin's book was out of favour for a long time after his death. The climate of opinion has changed now, and Ekman's superb edition was a major publishing event and has been enthusiastically welcomed.

As must be clear by now, I think that the exercise of imagination and ingenuity as expressed in literature supports Darwin's view. It would not be possible to read and enjoy literature from a time remote from our own, or from a culture that was profoundly different from our own, unless we shared some common emotional ground, some deep reservoir of assumptions, with the writer. An annotated edition that clarifies matters of historical circumstance or local custom or language is always useful, but it's never fundamentally necessary to a reading. What we have in common with each other is just as extraordinary in its way as all our exotic differences.

I mentioned earlier the parochial and the universal as polarities in literature. One might think of

literature as encoding both our cultural and genetic inheritance. Each of these two elements, genes and culture, has had a reciprocal shaping effect, for as primates we are intensely social creatures, and our social environment has exerted over time a powerful adaptive pressure. This gene-culture co-evolution, elaborated by E. O. Wilson among others, dissolves the oppositions of nature versus nurture. If one reads accounts of the systematic non-intrusive observations of troupes of bonobo – bonobos and common chimps rather than Darwin's baboons are our closest relatives – one might see rehearsed all the major themes of the English nineteenth-century novel: alliances made and broken, individuals rising while others fall, plots hatched, revenge, gratitude, injured pride, successful and unsuccessful court-ship, bereavement and mourning. Approximately five million years separate us and the bonobos from our common ancestor – and given that a lot of this coming and going is ultimately about sex (I'm talk-ing here about bonobos *and* the nineteenth-century novel) that is a long time during which, cumulatively, successful social strategies effect the distribution of certain genes and not others.

That we have a nature, that its values are self-evident to us to the point of invisibility, and that it would be a different nature if we were, say, termites, was the case E. O. Wilson was making when he

conjured a highly educated 'Dean of Termitities', who delivers a stirring commencement day address to his fellow termites:

> Since our ancestors, the macrotermitine termites, achieved 10 kilogram weight and larger brains during their rapid evolution through the later Tertiary period and learned to write with pheromone script, termitistic scholarship has refined ethical philosophy. It is now possible to express the de-ontological imperatives of moral behaviour with precision. These imperatives are mostly self-evident and universal. They are the very essence of termity. They include the love of darkness and of the deep saprophytic, basidiomycetic penetralia of the soil; the centrality of colony life amidst a richness of war and trade among the colonies; the sanctity of the physiological caste system; the evil of personal reproduction by worker castes; the mystery of deep love for reproductive siblings, which turns to hatred the instant they mate; rejection of the evil of personal rights; the infinite aesthetic pleasure of pheromenal song; the aesthetic pleasure of eating from nestmates' anuses after the shedding of the skin; the joy of cannibalism and surrender of the body for consumption when sick or injured . . . Some termitistically inclined scientists, particularly the ethologists and sociobiologists, argue that

our social organisation is shaped by our genes and that our ethical precepts simply reflect the peculiarities of termite evolution. They assert that ethical philosophy must take into account the structure of the termite brain and the evolutionary history of the species. Socialisation is genetically channelled and some forms of it all but inevitable. This proposal has created major academic controversy . . .

That is to say, whether it's a saga, a concrete poem, a Bildungsroman or a haiku, and regardless of when it was written and in what colony, you would just *know* a piece of termite literature as soon as you had read a line or two. Extrapolating from the termite literary tradition, we can say that our own human literature does not define human nature so much as exemplify it.

If there are human universals that transcend culture, then it follows that they do not change, or they do not change easily. And if something does change in us historically, then by definition it is not human nature that has changed, but some characteristic special to a certain time and circumstance. And yet there are writers who like to make their point by assuming that human nature is a frail entity, subject to sudden lurches – exciting revolutionary improvements or deeply regrettable deterioration, and defining the moment of the change has always

been an irresistible intellectual pursuit. No one, I think, has yet exceeded Virginia Woolf for precision in this matter, though she does allow a certain ironic haziness about the actual date: 'On or about December 1910', she wrote in her essay 'Character in Fiction', 'human character changed.' Woolf of course was preoccupied with the great gulf, as she saw it, that separated her generation from her parents'. The famous anecdote may or may not be true, but one hopes it was. It has Lytton Strachey entering a drawing room in 1908, encountering Virginia and her sister, pointing to a stain on Vanessa's dress and enquiring, 'Semen?' 'With that one word', Virginia wrote, 'all barriers of reticence and reserve went down.' The nineteenth century had officially ended. The world would never be the same again.

I remember similar apocalyptic generational claims made in the sixties and early seventies. Human nature changed forever, it was claimed at the time, in a field near Woodstock in 1967, or in the same year with the release of *Sergeant Pepper*, or the year before on a certain undistinguished street in San Francisco. The Age of Aquarius had dawned, and things would never be the same again.

Less light-headed than Virginia Woolf, but equally definitive, was T. S. Eliot in his essay 'The Metaphysical Poets'. He discovered that in the seventeenth century 'a dissociation of sensibility set in, from

which we have never recovered'. He was, of course, speaking of English poets, who 'possessed a mechanism of sensibility which could devour any kind of experience', but I think we can assume that he thought they generally shared a biology with other people. His theory, which, as he conceded, was perhaps too brief to carry conviction, expresses both Eliot's regret (this dissociation was not a good thing) and his hopes (this dissociation could be reversed by those modern poets who would redefine modern sensibilities to his prescription).

Jacob Burkhardt, defining his own choice moment in *The Civilisation of the Renaissance in Italy*, discerned a blossoming, not simply in human nature, but in consciousness itself: 'In the Middle Ages', he wrote,

> both sides of human consciousness – that which was turned within as that which was turned without – lay dreaming or half-awake beneath a common veil. Man was conscious of himself only as a member of a race, people, party, family, or corporation . . . But at the close of the thirteenth century, Italy began to swarm with individuality; the ban laid upon human personality was dissolved.

The French historian Philippe Aries defined a radical shift in human emotions in the eighteenth

century when parents began to feel a self-conscious love for their children. Before then, a child was little more than a tiny, incapable adult, likely to be carried off by disease and therefore not worth investing with too much feeling. A thousand medieval tombstones and their heartfelt inscriptions to a departed child may have provided the graveyard for this particular theory, but Aries' work demonstrates a secondary or parallel ambition in the pursuit of the defining moment of change in human nature – that is, the aim of locating the roots of our modernity. This is more or less central to the project of intellectual history – to ask at which moment, in which set of circumstances, we became recognisable to ourselves. At least some of these candidates will be familiar to you: the invention of agriculture 10,000 years ago, or, perhaps closely related, the expulsion from the Garden of Eden. Or the writing of *Hamlet*, which features a man so anguished, bored, indecisive and generally put-upon by the fact of his own existence that we welcome him into our hearts and find no precursor for him in literature. We can fix the beginnings of the modern mind in the scientific revolution of the seventeenth century; the agricultural or industrial revolutions which gathered populations into cities, and eventually made possible mass consumption, mass political parties, mass communication; with the writings of Kafka, a most artfully or wilfully

dissociated sensibility; or with the invention of writing itself, a mere several thousand years ago, which made possible an exponential increase in the transmission of culture; the publication of Einstein's Special and General Theories, the first performance of *The Rite of Spring*, the publication of Joyce's *Ulysses*, or the dropping of a nuclear weapon on Hiroshima, after which we accepted, whether we wanted it or not, stewardship for the entire planet. Some used to plump for the storming of the Winter Palace, though I'd prefer to that the radically unadorned, conversationally reflective early poetry of Wordsworth; or by association, the English or French Enlightenments and the invention of universal human rights.

The biological view, on the other hand, is long and, by these terms, unspectacular, though I would say no less interesting: one speaks not of a moment, but of an immeasurable tract of irretrievable time whose traces are a handful of bones and stone artefacts which demand all our interpretative genius. With the neo-cortex evolving at the astonishing rate of an extra teaspoon of grey matter every hundred-thousand years, hominids made tools, acquired language, became aware of their own existence and that of others, and of their mortality, took a view on the afterlife, and accordingly buried their dead. Possibly the Neanderthals who fell into extinction

30,000 years ago were the first into the modern age. But they just weren't modern enough to survive the pace.

You could say that what is pursued in all these accounts is the secular equivalent of a creation myth. Literary writers seem to prefer an explosive, decisive moment, the miracle of a birth, to a dull continuum of infinitesimal change. More or less the whole time-span of culture can be embraced when we ask, Who is the oldest, who is the *ur*, modern human being: mitochondrial Eve, or Alan Turing?

Our interest in the roots of modernity is not just a consequence of accelerating social change: implicit in the idea of the definitive moment, of rupture with the past, is the notion that human nature is a specific historical product, shaped by shared values, circumstances of upbringing within a certain civilisation – in other words, that there is no human nature at all beyond that which develops at a particular time and in a particular culture. By this view the mind is an all-purpose, infinitely adaptable computing machine operating a handful of wired-in rules. We are born tabula rasa, and it is our times that shape us.

This view, known to some as the Standard Social Science Model, and to others as environmental determinism, was the dominant one in the twentieth century, particularly in its first half. It had its roots in anthropology, especially in the work of Margaret

Mead and her followers, and in behavioural psychology. Writing in *Sex and Temperament in Three Primitive Societies*, published in 1935, Mead wrote: 'We are forced to conclude that human nature is almost unbelievably malleable, responding accurately and contrastingly to contrasting cultural conditions.' This view found endorsement across the social sciences, and solidified in the post-war years into a dogma that had clear political dimensions. There was a time when to challenge it with reference to a biological dimension to existence would be to court academic, and even social, pariah status. Like Christian theologians, the cultural relativists freed us from all biological constraints, and set mankind apart from all other life on earth. And within this view, the educated man or woman pronouncing on a favoured date for the transformation of human nature would be on firm ground epistemologically – we are what the world makes us, and when the world changes dramatically, then so do we in our essentials. It can all happen, as Virginia Woolf observed for herself, 'on or about December 1910'.

The famous behaviourist, John Watson, Professor of Psychology at Johns Hopkins, published an influential book on child-rearing in 1928. As Christina Hardyment showed in her marvellous book, *Dream Babies*, there is hardly a better window into the collective mind of a society, its view of human nature,

than the childcare handbooks it produces. Watson wrote:

> Give me a dozen healthy infants, well-formed, and my own specified world to bring them up in and I'll guarantee to take any one at random and train him to become any kind of specialist I might select – doctor, lawyer, merchant chief, and yes, even beggarman and thief, regardless of his talents, penchants, tendencies, abilities, vocations and race of his ancestors.

Human nature was clay in his hands. I can't help feeling that the following passage from Watson's childcare book, *The Psychological Care of Young Infants*, beyond its unintentional comedy, reflects or foretells a century of doomed, tragic social experiments in shaping human nature, and shows us a skewed science, devoid of evidence, and no less grotesque than the pseudo-science that perverted Darwin's work to promote theories of racial supremacy:

> The sensible way to bring up children is to treat them as young adults. Dress them, bathe them with care and circumspection. Let your behaviour always be objective and kindly firm. Never hug and kiss them. Never let them sit in your lap. If you must, kiss them once on the forehead when they say

goodnight. Shake hands with them in the morning. Give them a pat on the head when they make a good job of a difficult task ... Put the child out in the backyard a large part of the time ... Do this from the time that it is born ... Let it learn to overcome difficulties almost from the moment of birth ... away from your watchful eye. If your heart is too tender, and you must watch the child, make yourself a peephole, so that you can see without being seen, or use a periscope.

Watson's book, hugely successful at the time, was pronounced by *Atlantic Monthly* to be 'a godsend to parents'.

The ideas of Mead and Watson, who were simply prominent figures among many promoting the near infinite malleability of human nature, found general acceptance in the public, and in the universities, where their descendants flourish today in various forms. No one should doubt that some good impulses lay behind the Standard Model. Margaret Mead in particular, working at a time when the European empires had consolidated but had not yet begun to crumble, had a strong anti-racist element to her work, and she was determined to oppose the condescending view of primitive inferiority and to insist that each culture must be judged in its own terms. When Mead and Watson were at their most active,

the Soviet revolution still held great hopes for mankind. If learning makes us what we are, then inequalities could be eliminated if we shared the same environment. Educate parents in the proper methods of childcare, and new generations of improved people would emerge. Human nature could be fundamentally re-moulded by the makers of social policy. We were perfectible, and the wrongs and inequalities of the past could be rectified by radical alterations to the social environment. The cruelties and absurdities of Social Darwinism and eugenics and, later, the new threat posed by the social policies of Hitler's Germany, engendered a disgust with the biological perspective that helped entrench a belief in a socially determined nature that could be engineered for the better of all.

In fact, the Third Reich cast a long shadow over free scientific enquiry in the decades after the Second World War. Various branches of psychology were trapped by intellectual fear, deterred by recent history from considering the mind as a biological product of adaptive forces, even while, in nearby biology departments, from the 1940s onwards, Darwinism was uniting with Mendelian genetics and molecular biology to form the powerful alliance known as the Modern Synthesis.

In the late fifties, the young Paul Ekman, who had no firm convictions of his own, set off for New Guinea

with head-and-shoulder photographs of modern Americans expressing various emotions – surprise, fear, disgust, joy and so on. He discovered that his sample group of Stone Age Highlanders, who had had no, or virtually no, contact with the modern world, were able to make up easily recognisable stories about each expression. They also mimed for him the facial expressions in response to stories he gave them – you come across a pig that has been dead for some days. His work, and later, cleverly designed experiments with Japanese and Americans, which took into account the display rules of the different cultures, clearly vindicated Darwin's conclusions. As Ekman writes:

> Social experience influences attitudes about emotion, creates display and feeling rules, develops and tunes the particular occasions which will most rapidly call forth an emotion. The *expression* of our emotions, the particular configurations of muscular movements, however, appear to be fixed, enabling understanding across generations, across cultures, and within cultures between strangers as well as intimates.

Before leaving for New Guinea he had paid a visit to Margaret Mead. Her firm view was that facial expressions differ from culture to culture as much as customs and values. She was distinctly cool about

Ekman's research. And yet towards the end of her life she explained in her autobiography in 1972 that she and her colleagues had held back from the consideration of the biological bases of behaviour because of anxieties about the political consequences. How strange, this reversal of historical circumstances, that for Mead universality in expression or in human nature should appear to lend support to racism, while for Darwin such considerations undermined its flimsy theoretical basis.

Mead and her generation of anthropologists, arriving at a Stone Age settlement with their notebooks, gifts and decent intentions, did not fully understand (though Darwin, along with most novelists, could have told them), as they exchanged smiles and greetings with their subjects, what a vast pool of shared humanity, of shared assumptions, was necessary, and already being drawn on, for them to do their work. As the last of these precious cultures have vanished, the data was revisited. Donald Brown, in his book *Human Universals* (1991), compiled a list of what human individuals and societies hold in common. It is both long and, given the near infinite range of all possible patterns of behaviour, quite specific. When reading it, it is worth bearing in mind Wilson's termite dean. Brown includes – I'm choosing at random – tool making, preponderant right-handedness, specific childhood fears, knowledge

that other people have an inner life, trade, giving of gifts, notions of justice, importance of gossip, hospitality, hierarchies and so on. What's interesting about Brown's characterisation of what he calls the 'Universal People', who incorporate all the common, shared features of mankind, is the number of pages he devotes to language – again quite specific. For example, Universal People language has contrasts between vowels and contrasts between stops and non-stops. Their language is symbolic, invariably contains nouns, verbs and the possessive. Extra proficiency in language invariably confers prestige. This, surely, at the higher level of mental functioning, is what binds the human family. We know now that no blank-disk all-purpose machine could learn language at the speed and facility that a child does. A three-year-old daily solves scores of ill-posed problems. An instinct for language is a central part of our nature.

On our crowded planet, we are no longer able to visit Stone Age peoples untouched by modern times. Mead and her contemporaries would never have wanted to put the question, What is it that we hold in common with such people? and anthropologists no longer have the opportunity of first contact. We can, however, reach to our bookshelves. Literature must be our anthropology. Here is a description – 2,700 years old – of a woman who has been waiting

for more than two decades for her beloved husband
to come home. Someone has told her that he has at
last arrived, and is downstairs, and that she must go
and greet him. But, she asks herself, is it really him?

> She started down from her lofty room, her heart
> in turmoil, torn . . . should she keep her distance,
> probe her husband? Or rush up to the man at once
> and kiss his head and cling to both his hands?
> As soon as she stepped over the stone threshold,
> slipping in, she took a seat at the closest wall
> and, radiant in the firelight, faced Odysseus now.
> There he sat, leaning against the great central column,
> eyes fixed on the ground, waiting, poised for whatever
> > words
> his hardy wife might say when she caught sight of him.
> A long while she sat in silence . . . numbing wonder
> filled her heart as her eyes explored his face.
> One moment he seemed . . . Odysseus to the man,
> > to the life –
> the next, no, he was not the man she knew,
> a huddled mass of rags was all she saw.

So, still uncertain, Penelope tells Odysseus they'll
sleep in separate rooms, and she gives orders for
the marriage bed to be moved out of the bedroom.
But of course, he knows this bed can't be moved – he
knocked it together himself, and reminds her just

how he did it. Thus he proves beyond doubt he really is her husband; but now he's upset that she thought he was an imposter, and they're already heading for a marital spat.

> *Penelope felt her knees go slack, her heart surrender,*
> *recognising the strong clear signs that Odysseus offered.*
> *She dissolved in tears, rushed to Odysseus, flung*
>> *her arms*
> *around his neck and kissed his head and cried out,*
> *'Odysseus – don't flare up at me now, not you,*
> *always the most understanding man alive!*
> *The gods, it was the gods who sent us sorrow –*
> *they grudged us both a life in each other's arms*
> *from the heady zest of youth to the stoop of old age.*
> *But don't fault me, angry with me now because I failed,*
> *at the first glimpse, to greet you, hold you, so . . .*
> *In my heart of hearts I always cringed with fear*
> *some fraud might come, beguile me with his talk.*

Customs may change – dead suitors may be lying in the hallway, with no homicide charges pending – but we recognise the human essence of these lines. Within the emotional and the expressive we remain what we are. As Darwin put it in his conclusion to the *Expression*, 'the language of the emotions . . . is certainly of importance for the welfare of mankind'. In Homer's case we extend Ekman's 'understanding

across the generations' – a hundred and thirty of them at least.

THE HUMAN GENOME Sequencing Consortium concluded a report in *Nature* in 2001 with these words: 'Finally, it has not escaped our notice that the more we learn about the human genome, the more there is to explore.' This form of respectful echoing within the tradition should appeal to those who admire literary modernism. When the sequencing of the human genome was completed, it was reasonable to ask whose genome this was anyway? What lucky individual had been chosen to represent us all? Who is the universal person? The answer was that the genes of fifteen people were merged into just the sort of composite, plausible, imaginary person a novelist might dream up, and here we contemplate the metaphorical convergence of these two noble and distinct forms of investigation into our condition, literature and science. That which binds us, our common nature, is what literature has always, knowingly and helplessly, given voice to. And it is this universality which the biological sciences, entering another exhilarating phase, are set to explore further.

Hilary Lecture, Oxford, 2003

The Originality of the Species

IN JUNE 1858 a slender package from Ternate, an island off the Dutch East Indies, arrived for Charles Darwin at his country home in Downe, Kent. He may well have recognised the handwriting as that of Alfred Wallace, with whom he had been in correspondence and from whom he was hoping to receive some specimens. But what Darwin found in the package along with a covering letter was a short essay. And this essay was to transform Darwin's life.

Wallace's twenty pages, so it seemed to their reader on that momentous morning, covered all the principal ideas of evolution by natural selection that Darwin had been working on for more than two decades and which he thought were his exclusive possession – and which he had yet to publish. Wallace, working alone, with very little in the way of

encouragement or money, drew from his extensive experience of natural history, gathered while sending back specimens for collectors. He articulated concisely the elements as well as the sources familiar to Darwin: artificial selection, the struggle for survival, competition and extinction, the way species changed into different forms by an impersonal, describable process, by a logic that did not need the intervention of a deity. Wallace, like Darwin, had been influenced by the geological speculations of Charles Lyell, and the population theories of Thomas Malthus.

In a covering letter Wallace politely asked Darwin to forward the essay to Lyell. Now, Darwin could have quietly destroyed Wallace's package and no one would have known a thing – it had taken months to arrive, and the mail between the Dutch East Indies could hardly have been reliable in the mid-nineteeth century. But Darwin was an honourable man, and knew that he could never live with himself if he behaved scurrilously. And yet he was in anguish. In his own letter to Lyell that accompanied Wallace's essay, which Darwin forwarded the same day, he lamented: 'So all my originality, whatever it may amount to, will be smashed.' He was surprised at the depth of his own feelings about priority, about being first. As Janet Browne notes in her biography of Darwin, the excitement of discovery in his work had

been replaced by profound anxieties about possession and ownership. He was ambushed by low emotions – mortification, irritation, rancour. In a much-quoted phrase, he was 'full of trumpery feelings'.

He had held off publishing his own work in a desire to perfect it, to amass instances, to make it as immune to disproof as he could. And, of course, he was aware of his work's theological implications – and that had made him cautious too. But he had been 'forestalled'. That day he decided he must yield priority to Wallace. He must, he wrote, 'resign myself to my fate'.

Within a day he had even more pressing concerns. His fifteen-year-old daughter, Henrietta, fell ill and there was fear that she had diphtheria. The next day the baby, Charles, his and Emma's tenth and last child, developed a fever. Soon, Lyell was urging Darwin to concede nothing and to publish a 'sketch', which would conclusively prove Darwin's priority over Wallace.

Taking his turn to nurse the sick baby, Darwin could decide nothing, and left the matter to his close friend Joseph Hooker, and to Lyell. They discussed the matter and proposed that Darwin's 'sketch' should be read aloud along with Wallace's essay at a meeting of the Linnaean Society, and the two pieces would be published in the society's journal. Speed was important. Wallace might have sent his essay to

a magazine, in which case Darwin's priority would be sunk, or at least compromised. There was no time to ask Wallace's permission to have his essay read.

But before Darwin could consider the proposal, the baby died. In his grief, Darwin hastily made a compilation for Hooker to edit. An 1844 set of notes, though out of date, seemed to make a conclusive case for priority, for they bore Hooker's pencilled marks. A more recent 1857 letter to Asa Grey, the professor of botany at Harvard, set out concisely Darwin's thoughts on evolution by natural selection.

Lyell, Hooker and Darwin were eminent insiders in the closed world of Victorian metropolitan science. Wallace was the outsider. He came from a far humbler background, and if he was known at all, it was as a provider of material for gentlemen experts. It was customary at the Linnaean Society for double contributions to be read in alphabetical order. And so, in Darwin's absence – he and Emma buried their baby that day – his 1844 notes were followed by his detailed 1857 letter, and then, almost as a footnote, came Wallace's 1858 essay.

DARWIN HAD DELVED far deeper over many years and certainly deserved priority. Wallace found it difficult to think through the implications of natural selection, and was reluctant in later years to allow that humans too were subject to evolutionary change.

The point, however, is Darwin's mortification about losing possession. As he wrote later to Hooker, 'I always thought it very possible that I might be forestalled, but I fancied that I had a grand enough soul not to care.'

Hooker began to press his friend to write a proper scientific paper on natural selection. Darwin protested. He needed to set out all the facts, and they could not be accommodated within a single paper. Hooker persisted, and so Darwin began his essay, which in time grew to become *On the Origin of Species*. In Browne's description, it suddenly released 'years of pent-up caution'. Back at Downe House, Darwin did not use a desk, but sat in an armchair with a board across his knees and wrote like a fiend. 'All the years of thought', writes Browne, 'climaxed in these months of final insight ... the fire within came from Wallace.'

The *Origin*, written in thirteen months, represents an extraordinary intellectual feat: mature insight, deep knowledge and observational powers, the marshalling of facts, the elucidation of near-irrefutable arguments in the service of a profound insight into natural processes. The reluctance to upset his wife Emma's religious devotion, or to contradict the theological certainties of his scientific colleagues, or to find himself in the unlikely role of iconoclast, a radical dissenter in Victorian society – all

were swept aside for fear of another man taking possession of and getting credit for the ideas he believed to be his.

IN MODERN TIMES, we have come to take for granted in art – literature as well as painting and cinema – the vital and enduring concept of originality. Despite all kinds of theoretical objections, it remains central to our notion of quality. It carries with it an idea of the *new*, of something created in a godlike fashion out of nothing. 'Perfectly unborrowed', as Coleridge said of Wordsworth's poetry. Originality is inseparable from a powerful sense of the individual, and the boundaries of this individuality are strongly protected.

In traditional societies, conformity to certain respected patterns and conventions was the norm. The pot, the carving, the exquisite weaving needed no signature. By contrast, the modern artefact bears the stamp of personality. The work *is* the signature. The individual truly possesses his or her own work, has rights in it, and is defined by it. It is private property that cannot be trespassed on. A great body of law has grown up around this possessiveness. Countries that do not sign up to the Berne Convention and other international agreements relating to intellectual property rights find themselves excluded from the mainstream of a globalised culture. The artist owns her work, and sits glowering over it, like a broody

hen on her eggs. We see the intensity of this fusion of originality and individuality whenever a plagiarism scandal erupts.

The dust-jacket photograph, though barely relevant to an appreciation of a novel, seals the ownership. This is me, it says, and what you have in your hands is mine. Or is me. We see it too in the cult of personality that surrounds the artist – individuality and personality are driven to inspire near-religious devotion. The coach parties at Grasmere, the cult of Hemingway or Picasso or Neruda. These are big figures – their lives fascinate us sometimes more than their art.

This fascination is relatively new. In their day, Shakespeare, Bach, Mozart, even Beethoven were not worshipped, they did not gleam in the social rankings the way their patrons did, or in the way that Byron or Chopin would do, or in the way a Nobel Prize-winner does today. How the humble artist was promoted to the role of secular priest is a large and contentious subject, a sub-chapter in a long speculation about individuality and modernity. The possible causes make a familiar list – capitalism, a growing leisured class, the Protestant faith, the Romantic movement, new technologies of communication, the elaboration of patent law following the Industrial Revolution. Some or all of these have brought us to the point at which the identification of the individual

and her creativity is now complete and automatic and unquestionable. The novelist today who signs her name in her book for a reader, and the reader who stands in line waiting for his book to be signed, collude in this marriage of selfhood and art.

There is an antithetical notion of artistic creation, and though it has been expressed in different forms by artists, critics and theoreticians, it has never taken hold outside the academies. This view holds that, of course, no one escapes history. Something cannot come out of nothing, and even a genius is bound by the constraints and opportunities of circumstance. The artist is merely the instrument on which history and culture play. Whether an artist works within his tradition or against it, he remains its helpless product. The title of Auden's essay 'The Dyer's Hand' is just a mild expression of the drift. Techniques and conventions developed by predecessors, perspective, say, or free indirect style (the third-person narrative coloured by a character's subjective state) are available as ready-made tools and have a profound effect. Above all, art is a conversation conducted down through the generations. Meaningful echoes, parody, quotation, rebellion, tribute and pastiche all have their place. Culture, not the individual talent, is the predominant force; in creative-writing classes, young writers are told that if they do not read widely, they are more likely to be

helplessly influenced by those whose work they do not know.

Such a view of cultural inheritance is naturally friendly to science. Darwin worked against a background of all kinds of evolutionary views, including those of his grandfather, Erasmus. Darwin relied on the observations of animal breeders, pigeon fanciers, natural historians, as well as the work of Malthus and Lyell. Einstein, another great creator, could not have begun his Special Theory of Relativity without the benefit of countless others, including Hendrik Lorentz and Max Planck. He was entirely dependent on mathematicians to give expression to his ideas. (Newton's much-cited claim to have stood on the shoulders of giants was inverted some years ago to illustrate the potency of predecessors in science: 'If I have seen less far than others, it was because giants were standing on my shoulders.')

Given the tools that were available to scientists in the mid-twentieth century, including X-ray crystallography, and given the suppositions that were in the air, and the different groups that were working in this field, DNA would have been described sooner or later by someone or other. It should hardly matter then, in the realms of pure rationality and scientific advance, who actually got there first. If it had been Linus Pauling and not Crick and Watson, what

difference would it have made in the sum of things? But what a difference being ahead by a few months made to the lives of Crick and Watson.

In terms of the general good, can it matter whether Joseph Priestley or Antoine Lavoisier discovered oxygen, or whether Isaac Newton or Gottfried Leibniz devised the calculus?

Consider another celebrated moment of priority-anxiety. It came at the end of a ten-year process during which Einstein pursued the ambitious project of 'generalising' his Special Theory of Relativity, formulated in 1905. As his thinking developed in the years after its publication, he predicted that light would be influenced by gravitation. His biographer Walter Isaacson points out that Einstein's success thus far had 'been based on his special talent for sniffing out the underlying physical principles of nature', leaving to others the more mundane task of providing the best mathematical expression. 'But', as Isaacson notes, 'by 1912 Einstein had come to appreciate that maths could be a tool for discovering – and not merely describing – nature's laws.'

Isaacson quotes the physicist James Hartle: 'The central idea of general relativity is that gravity arises from the curvature of space-time.' Two complementary processes were to be described: how matter is affected by a gravitational field, and how matter generates a gravitational field in space-time and causes

it to curve. These startling, near-ungraspable notions were eventually to find expression in Einstein's adaptation of the non-Euclidean geometry of tensors devised by the mathematicians Riemann and Ricci. By 1912 Einstein had come close to a mathematical strategy for an equation, but then he turned aside, looking for a more physics-based route. It was only partially successful, and he had to be satisfied with publishing with his colleague Marcel Grossmann an outline of a theory, the famous '*Entwurf*' of 1913, which, as Einstein came to realise, contained important errors.

The upheavals of the First World War, and Einstein's struggle against German nationalism among scientific colleagues, his ongoing attempts to see his young sons in Zurich and to obtain a divorce from their mother form the background to another extraordinary intellectual supernova, extending not over thirteen months this time, but four outstanding weeks.

In June of 1915 Einstein lectured on the *Entwurf* at the University of Göttingen. The lectures were a great success. Also, in private conversations with the eminent German mathematician David Hilbert, a fellow pacifist, Einstein explained relativity and what he was attempting, and the mathematical problems he was encountering. Afterwards, Einstein declared himself enchanted with Hilbert. He seemed

to understand right down to the fine details what Einstein was trying to achieve, and the mathematical obstacles in his way.

In fact, Hilbert understood rather too well, and soon he was working hard to find a formulation of his own for a general theory, just as Einstein was discovering more errors and contradictions in the *Entwurf*. He abandoned it in October and turned back to the maths-based strategy of 1912. And thus, painfully conscious of Hilbert, the superior mathematician, on his heels, Einstein began what Isaacson, surely rightly, calls 'the most concentrated frenzies of scientific creativity in history'. As he worked on his theory, he was presenting his ideas immediately to the Prussian Academy in a set of four weekly lectures, beginning on 4 November 1915.

By his third lecture, Einstein's theory in its present state accurately predicted the shift in Mercury's orbit – he was, he wrote to a friend, 'beside myself with joyous excitement'. Just days before Einstein was about to give his final lecture, Hilbert submitted his own formulation of general relativity to a journal in an essay with the not so humble title of 'The Foundation of Physics'. Einstein wrote bitterly to a friend: 'In my personal experience I have hardly come to know the wretchedness of mankind better.'

Unlike Wallace, who worked independently of Darwin, Hilbert was trying to give mathematical

expression to theories that were Einstein's. Never-theless, Einstein, like Darwin, was driven to a great creative outpouring for fear of losing priority. The formulation he gave in his final lecture on 28 November was described by the physicist Max Born as 'the greatest feat of human thinking about nature, the most amazing combination of philosoph-ical penetration, physical intuition and mathematical skill'. Einstein himself said of the theory that it was of 'incomparable beauty'.

The Einstein-Hilbert priority dispute still rum-bles on in its small way. But it should be noted that both Wallace and Hilbert were quick and generous to concede priority to Darwin and Einstein. If Ein-stein's friendship with Hilbert became strained during that momentous month of November 1915, their friendship was soon re-established.

AS CHILDREN WE race each other to be first into the sea. There have been heroic, sometimes fatal races to be first at the North or South Poles, or round the North-West Passage or up this river or across that desert. Sometimes, intense nationalistic pas-sions are involved. First to swim or fly across the Channel, first to ascend into space, first on the Moon, on Mars – these great endeavours, for all their heroism and technical accomplishment, have a child-like quality.

In literature, everyone is first. We do not need to ask who was first to write *Don Quixote*. Better, in fact, to consider the possibility of being the second, like Pierre Menard, who in Borges's famous story independently reconceives, centuries after Cervantes, the entire novel, down to the last word. The worst novelist in the world can at least be assured that he will be the first to write his terrible novel. And, mercifully, the last. And yet, to be first, to originate, to be original, is key to the quality of a work of literature. However minimally, it must advance – in subject matter, in means of expression – our understanding of ourselves, of ourselves in the world.

But novelists are the grateful inheritors of an array of techniques and conventions and subject matter, which themselves are the products of social change. I've mentioned free indirect style, first deployed in extended form by Jane Austen. Samuel Richardson's novel *Clarissa* was perhaps the first to describe in exacting detail and at length the qualities of a subjective mental state. Nineteenth-century novelists bequeathed penetrating and sophisticated means for delineating character. A long time had to pass before a novelist troubled to inhabit the mind of a child. In *Ulysses*, Joyce made a new poetry out of the minutiae of the everyday. And he and modernists like Virginia Woolf found new means of representing the flow of consciousness that now are common, even in

children's books. But Richardson, Austen, Joyce and Woolf were inheritors in their turn. They sat on the shoulders of giants too.

Darwin and Einstein came first and were overwhelmed by celebrity and profound respect, and became icons in the culture, while Wallace and Hilbert languished in relative obscurity. And this 'first', this originality, is precisely defined. Not first along an absolute Newtonian timeline, but first in a recognisable and respectable public forum. Hence the Linnaean Society, hence the Prussian Academy – presentations made at speed and under immense pressure.

Nineteenth-century science had teetered for decades on the edge of evolutionary ideas, and if Darwin – or for that matter Wallace – had not given expression to the idea of evolution by natural selection, others surely would have. The same biological realities confronted everyone, and taxonomy was at an advanced stage.

Likewise, it is inconceivable that the brilliant generation that laid down the foundations of classical quantum mechanics in the first thirty years of the twentieth century would not have found a means of binding matter, energy, space and time, though their routes may have differed from Einstein's, and they may not at first have achieved it with such elegant economy by way of Riemann's tensor.

To be first, to be original in science, matters profoundly. Laboratories race each other to publication. Powerful passions are involved, and Nobel prizes too. To be for ever associated with a certain successful idea is a form of immortality. In longing for it, scientists demonstrate a concern for themselves as creators, as irreplaceable makers. In this we see a parallel with the fiercely individualistic world of novelists, poets, artists and composers who know in their hearts that they are utterly reliant on those who went before them. In both, we see a human face.

I WANT TO touch on another point of convergence between the arts and science. And this is the question of aesthetics. In 1858 and 1915, Darwin and Einstein, driven in part by the somewhat ignoble or worldly ambition to be first, redirected not only the course of science, but redefined our sense of ourselves. These twin revolutions, barely sixty years apart, represent the most profound as well as the most rapid shift and dislocation in human thought that has ever occurred. This rapidity is worth considering. The counter-intuitive notion that the Earth revolves around the Sun took generations to spread and take hold across Europe. Likewise, the brilliant invention of three- and four-crop rotation. A teeming microscopic world was available to medicine from the time in the 1670s onwards when Antoni van

Leeuwenhoek began sending his observations to the Royal Society in London. But stubborn tradition-bound medicine kept its back turned on science, and it took almost another 200 years before an understanding of harmful microorganisms and the concept of anti-sepsis shaped medical practice.

A theory that suggested the relatedness of all species, including humans, was a challenge to dignity, and the church found it hard at first to accept the suggestion that species were not fixed, unchanging and recently made by God. Generally, however, Darwin's ideas explained too much, too well, and were too much in accord with new observations in geology to be resisted, especially by biologists, and many English clergymen with country livings were good naturalists and could immediately grasp the theory's utility. What is interesting about the publication of *On the Origin of Species* is the rapidity of its acceptance.

Einstein's theory could be empirically tested by observing the degree of refraction of starlight by the Sun, best achieved at a full eclipse. Various expeditions were sent from 1918, and though they returned what seemed a positive result, in reality the margin of error in measurements was too great to provide absolute confirmation. And, meanwhile, the theory was already in the textbooks by the late 1920s. Radio telescopes in the early 1950s provided the definitive

proof, and by then relativity theory was a staple of physics and astronomy.

The accelerated acceptance of Darwin and Einstein's work from 1859 and 1916 cannot be explained entirely by reference to their effectiveness or truthfulness. Here is what the great American biologist E. O. Wilson has to say about a scientific theory: 'The elegance, we can fairly say the beauty, of any particular scientific generalisation is measured by its simplicity relative to the number of phenomena it can explain.' Many physicists, notably Steven Weinberg, are convinced that it was the elegance, the sheer beauty, of Einstein's general theory that drove its rapid acceptance ahead of its empirical validation.

Those lucky enough to understand Paul Dirac's famous equation (it explains the spin of the electron and predicted the existence of anti-matter) speak of its intellectual daring and breathtaking beauty. This is a music most of us will never hear. The equation, as brief as Einstein's, can be found carved in stone in Westminster Abbey.

If one might make use of Darwin's theory to think about Einstein's, we could speculate that evolution has granted us only sufficient understanding of space and time as is necessary to function and reproduce effectively. The relentless logic of natural selection is not organised to grant organisms, even most humans, an intuitive grasp of the kinds of counter-intuitive

insights that the special and general theories of Einstein present.

Gravity may well be a function of the bending of space-time, matter and energy may lie along a continuum, but most of us cannot feel this as part of our immediate world. We are the evolved inhabitants of Middle Earth. You might say we continue to dwell in a Newtonian universe, but in fact it is one that would also be familiar to Jesus and Plato.

When a well-known scientist, John Wheeler, writes that 'matter tells space-time how to curve, and curved space-time tells matter how to move', we may or may not be impressed, but it is hard to reorient one's worldview accordingly, to abandon the sense that there is an absolute 'now' in every corner of the universe and that empty space is just a void ready to be filled, and cannot be bent, and is a distinct entity from time. The Einsteinian revolution may have redefined the absolute basics of matter, energy, space and time, but the limits of our mental equipment keep us in our evolutionary homelands, in the savannah of common sense.

On the other hand, as Steven Pinker has pointed out, the ramifications of natural selection are multiple. And, relatively, they are easily, if uneasily, understood: the Earth and life on it are far older than the Bible suggests. Species are not fixed entities created at one time. They rise, fall, become extinct,

and there is no purpose, no forethought in these patterns. We can explain these processes now without reference to the supernatural. We ourselves are related, however distantly, to all living things. We can explain our *own* existence without reference to the supernatural. We may have no purpose at all except to continue. We have a nature derived in part from our evolutionary past. Underlying natural selection are physical laws. The evolved material entity we call the brain is what makes consciousness possible. When it is damaged, so is mental function. There is no evidence for an immortal soul, and no good reason beyond fervent hope that consciousness survives the death of the brain.

It is testimony to the originality as well as the diversity of our species that some of us find such ramifications horrifying, or irritating, or self-evidently untrue and (literally) soulless, while others find them both beautiful and liberating and discover, with Darwin, 'grandeur in this view of life'. Either way, if we do not find our moments of exaltation in religious awe and the contemplation of a supreme supernatural being, we will find them in the contemplation of our arts and our science. When Einstein found that his general theory made correct predictions for the shift in Mercury's orbit, he felt so thrilled he had palpitations, 'as if something had snapped inside. I was,' he wrote, 'beside myself with

joyous excitement.' This is the excitement any artist can recognise. This is the joy, not of simple description, but of creation. It is the expression, common to both the arts and science, of the somewhat grand, somewhat ignoble, all-too-human pursuit of originality in the face of total dependence on the achievements of others.

Darwin Symposium, Santiago, Chile, 2009

A Parallel Tradition

THOSE WHO LOVE literature rather take for granted the idea of a literary tradition. In part, it is a temporal map, a means of negotiating the centuries and the connections between writers. It helps to know that Shakespeare preceded Keats who preceded Wilfred Owen, because lines of influence might be traced. And in part, a tradition implies a hierarchy, a canon; conventionally, it has Shakespeare dominant, like a lonely figurine on top of a wedding cake, and all the other writers arranged on descending tiers. In recent years the cake has seemed to many too inedibly male and middle-class and heterosexual. What remains undisputed is the value of the canon itself. To define a tradition is to make an argument and expect to be engaged.

Above all, a literary tradition implies an active

historical sense of a past, that lives in and shapes the present. Reciprocally, a work of literature produced now, infinitesimally shifts our understanding of what has gone before. You cannot value a poet alone, T. S. Eliot argued in 'Tradition and the Individual Talent', 'you must set him, for contrast and comparison, among the dead'. Eliot did not find it preposterous 'that the past should be altered by the present as much as the present is directed by the past'. We might discern the ghost of Jane Austen in a novel by Angus Wilson, or hear echoes of Wordsworth in a poem by Alice Oswald. Ideally, having read our contemporaries, we return to re-read the dead poets with a fresh understanding. In a living artistic tradition, the dead never lie down.

Can science and science writing, a vast and half-forgotten accumulation over the centuries, offer us a parallel living tradition? If it can, how do we begin to describe it? The problems of choice are equalled only by those of criteria. Literature does not improve; it changes. Science, on the other hand, as an intricate, self-correcting thought system, advances and refines its understanding of thousands of fields of study. This is how it derives its power and status. Science prefers to forget much of its past. It is constitutionally bound to a form of selective amnesia.

Is accuracy, being on the right track, or some approximation of it, the most important criterion for

selection? Or is style the final arbiter? The writings of Thomas Browne or Francis Bacon or Robert Burton contain many fine passages that we now know to be factually wrong – but we would surely not wish to exclude them. The tradition must keep a place for Aristotle and Galen because of the hold they had over people's minds for centuries. We have to beware of implying a Whig history of science, a history of the lonely but correct road that leads to the present. We need to remember the various discarded toys of science – the humours, the four elements, phlogiston, the ether and, more recently, protoplasm. Modern chemistry was born out of the futile ambitions of alchemy. Scientists who hurl themselves down blind alleys perform a service – they save everyone a great deal of trouble. They may also refine techniques along the way, and offer points of resistance, intellectual cantilevers, to their contemporaries.

I say all this somewhat dutifully, because there actually is a special pleasure to be shared when a scientist or science writer leads us towards the light of a powerful idea which in turn opens avenues of exploration and discovery leading far into the future, binding many different phenomena in many different fields of study. Some might call this truth. It has an aesthetic value that is not to be found in Galen's confident and muddled assertions about the nature of disease. For example, there is something of the

luminous quality of great literature when the twenty-nine-year-old Charles Darwin, just two years back from his *Beagle* voyage and twenty-one years before he will publish *On the Origin of Species*, confides to a pocket notebook the first hints of a simple, beautiful idea: 'Origin of man now proved . . . He who understands baboon would do more towards metaphysics than Locke.'

Far better, perhaps, to set aside issues of truth and inaccuracy, criteria and definitions. We know what we like when we taste it. Until recently, the purely literary tradition was never obliged to set out its terms. The work came first, and then the talk about it. In a sense, I am merely making an appeal for a grand parlour game: what might a scientific literary tradition be? Which books are going on our shelves? To propose is to ask to be challenged; already I suspect my own suggestions are too male, too middle-class, too Eurocentric.

Here is the opening of an essay – strictly speaking, a letter – on immunology.

It is whispered in Christian Europe that the English are mad and maniacs: mad because they give their children smallpox to prevent their getting it, and maniacs because they cheerfully communicate to their children a certain and terrible illness with the object of preventing an uncertain one. The English

on their side say: 'The other Europeans are cowardly and unnatural: cowardly in that they are afraid of giving a little pain to their children, and unnatural because they expose them to death from smallpox some time in the future.' To judge who is right in this dispute, here is the history of this famous inoculation which is spoken of with such horror outside England.

This is Voltaire, writing in the late 1720s during an extended visit to England, presenting a rare instance of a French intellectual impressed by English ideas. Voltaire wrote beautifully in his *Lettres philosophiques* – translated as *Letters on England* – on religion, politics and literature. He was delighted by the degree of political freedom he found here, by the powers of Parliament, the absence of religious absolutism and divine right. He attended Newton's funeral and was amazed that a humble scientist was buried like a king in Westminster Abbey. Crucially, he placed himself between a scientist and an interested public, and offered superb expositions of Newton's theories of optics and gravitation which still stand today. If you want to know what was daring and original in what Newton said, read Voltaire. He communicates the excitement of a new idea, and sets the highest standards of lucidity.

In 2001, when my son William came to study

biology at UCL he was advised to read no papers on genetics written before 1997. By 2003, estimates of the human genome had shrunk by a factor of five, or even six. Such is the headlong nature of contemporary science. But if we understand science merely as a band of light moving through time, advancing on the darkness, and leaving ignorant darkness behind it, always at its best only in the incandescent present, we turn our backs on an epic tale of ingenuity and heroic curiosity.

Here is a man who has polished a lens with infinite care. He has taken some water from a lake and has been studying it scrupulously, with an open mind:

> I found floating therein divers earthy particles and some green streaks, spirally wound serpent-wise and orderly arranged ... Other particles had but the beginning of the foresaid streak; but all consisted of very small green globules joined together; and there were very many small green globules as well ... These animalcules had divers colours, some being whitish and transparent, others with green and very glittering little scales ... And the motion of most of these animalcules in the water was so swift, and so various upwards, downwards and roundabout, that 'twas wonderful to see: and I judge that some of these little creatures were above a thousand times smaller than the smallest ones I have ever yet seen ...

This is Anton van Leeuwenhoek writing from Holland to the Royal Society in 1674, giving the first account of spirogyra, among other organisms. He sent his observations to the Royal Society over a period of fifty years, and it was no accident that he should have sent his letters there. At that time, in a small space, within a triangle formed by London, Cambridge and Oxford, and within a couple of generations, there existed nearly all the world's science. Newton, Locke, Hume (I think we need to include certain philosophers), Willis, Hooke, Boyle, Wren, Flamsteed, Halley: an incredible concentration of talent, and the core of our library – its classical moment.

I have never been persuaded by the common argument that religion and science inhabit different realms and are therefore not in conflict. That the dead inhabit an afterlife, that God exists and made the universe, that prayers are sympathetically heard, that the wicked are punished and the virtuous rewarded are statements about the world in which science takes a deep interest. When Christianity's hold on the world was total, free-thinking Greek and Roman writers of antiquity were largely lost to Medieval science (though not to scholarship in the Islamic lands). Lucretius's long-buried *De Rerum Natura*, rediscovered and highly influential in the early Renaissance, deserves a special place in the literary tradition of science. From the sixteenth

century onwards, it was slowly becoming clear that the Church had nothing much useful to say about cosmology, the curing of disease, the age of the earth, the origin of species or any other aspect of the material world. Here is a great scientist, often referred to as 'the father of physics' who has been found 'vehemently suspect of heresy' for promoting the idea that the earth is not at the centre of the solar system and moves around the sun. Under threat of torture by the Inquisition, he was forced to recant. He spent the rest of his days under house arrest.

> having before my eyes and touching with my hands the Holy Gospels, swear that I have always believed, do believe, and with God's help will in the future believe all that is held, preached and taught by the Holy Catholic and Apostolic Church . . . I must altogether abandon the false opinion that the sun is the centre of the world and immovable, and that the earth is not the centre of the world and moves and that I must not hold, defend or teach in any way whatsoever, verbally and in writing the said false doctrine . . .

In 1632 Galileo might or might not have whispered to himself as he signed, 'E pur si muove' (And yet it moves). We will never know. In effect, he pretended to agree that two plus two equals five. To summon

Orwell here is to remember that secular powers have also been hostile to free enquiry. Under Nazi and Soviet regimes science was grotesquely distorted for political ends. The Third Reich's perversion of Darwinian natural selection in the cause of a theory of racial superiority laid the ground for the Holocaust.

Being an earth-bound institution, science itself can hardly claim to be a purely objective pursuit. The canon is rich in human interest, with a history littered with aggressive competition, disputes over priority, accusations of intellectual theft and clashes of powerful personalities. James Watson's *The Double Helix*, published in 1968, is one of the great science books of the twentieth century. But its account of the first accurate description of the structure of DNA is highly personal. Watson's collaborators, Francis Crick and Maurice Wilkins (Rosalind Franklin was dead by this time) took strong exception to the book.

The Double Helix and, eight years later, Richard Dawkins's *The Selfish Gene* marked the beginnings of the golden age of science writing in our time. Dawkins drew on the work of a handful of scientists to make a creative synthesis of Darwinian natural selection and contemporary genetics that excited and delighted even those few who were already familiar with the concepts. It hastened a sea change in evolutionary theory, it affected profoundly the teaching of

biology, it enticed an enthusiastic younger genera-
tion into the subject and spawned a huge literature.

An important contribution to the development of
a living past in science writing was John Carey's
Faber Book of Science, a magisterial anthology, superbly
annotated. In it is the Galileo 'confession' I've just
cited. Carey includes a long extract from Thomas
Huxley's famous lecture, 'On a Piece of Chalk' to a
packed hall of working men in Norwich in 1868. The
talk contained the seductive sentence, 'A great chap-
ter in the history of the world is written in the
chalk...'

Huxley leads us back, of course, to Darwin. The
'Origin' apart, my favourite is *The Expression of
the Emotions in Man and Animals* in which he made
the case for emotions as human universals shared
across cultures. He also made an anti-racist argu-
ment for a common human nature. This was one of
the first science books to make use of photographs –
in this case, one of Darwin's babies bawling in a high
chair. The edition by Paul Ekman is an unsurpassed
work of scholarship. With a clear sense of a literary
tradition, the physicist, Steven Weinberg, in his book
Dreams of a Final Theory, revisited Huxley's lecture
on chalk in the light of contemporary theoretical
physics to make an eloquent case for reductionism.

Steven Pinker's application of Darwinian thought
to Chomskyan linguistics in *The Language Instinct* is

one of the finest celebrations of language I know. Among many other indispensable 'classics', I would propose E. O. Wilson's *The Diversity of Life* on the ecological wonders of the Amazon rainforest, and on the teeming micro-organisms in a handful of soil; David Deutsch's masterly account of the Many Worlds theory in *The Fabric of Reality*; Jared Diamond's melding of history with biological thought in *Guns, Germs and Steel*; Antonio Damasio's hypnotic account of the neuroscience of the emotions in *The Feeling of What Happens*; Matt Ridley, unweaving the opposition of nature and nurture in *Nature via Nurture*; and recently, the philosopher Daniel C. Dennett, conscious of Hume as well as Dawkins, laying out for us the memetics of faith in *Breaking the Spell*.

From Aristotle's empirical study of the marine biology of the Pyrrha lagoon on the island of Lesbos around 344 BC, through to Banks, Faraday, Tyndal, Gauss, Cajal, Einstein, Heisenberg – the scientific literary tradition is vast, rich and multi-lingual. It is a literature that should belong to us all, not just to those who practice science. This is a history of intellectual courage, hard work, occasional inspiration and every conceivable form of human failing. It is also an extended invitation to wonder, to pleasure. Just as we might sit around the kitchen table with friends and celebrate a TV programme, a song, a

movie without being actors, composers or directors, so we should be able to make the scientific tradition 'ours' and enjoy this feast of organised curiosity, this sublime achievement of accumulated creativity.

Adapted from a Guardian *article, 2006*

4

End of the World Blues

SINCE 1839, THE world inventory of photographs has been accumulating at an accelerating pace, multiplying into a near infinitude of images, into a resemblance of a Borgesian library. This haunting technology has been with us long enough now that we are able to look at a crowd scene, a busy street, say, in the late-nineteenth century and know for certain that every single figure is dead. Not only the young couple pausing by a park railing, but the child with a hoop and stick, the starchy nurse, the solemn baby upright in its carriage – their lives have run their course, and they are all gone. And yet, frozen in sepia, they appear curiously, busily, oblivious of the fact that they must die – as Susan Sontag put it, 'photographs state the innocence, the vulnerability

of lives heading towards their own destruction.'
'Photography,' she said,

> is the inventory of mortality. A touch of the finger
> now suffices to invest a moment with posthu-
> mous irony. Photographs show people being so
> irrefutably *there* and at a specific age in their lives;
> [they] group together people and things which a
> moment later have already disbanded, changed,
> continued along the course of their independent
> destinies.

So, one day, it could be the case with a photograph
of us all assembled here today in this hall. Imagine
us scrutinised in an old photograph two hundred
years hence, idly considered by a future beholder as
quaintly old-fashioned, possessed by the self-evident
importance of our concerns, ignorant of the date
and manner of our certain fate, and long gone. And
long gone, en masse.

We are well used to reflections on individual
mortality – it is the shaping force in the narrative of
our existence. It emerges in childhood as a baffling
fact, re-emerges possibly in adolescence as a tragic
reality which all around us appear to be denying,
then perhaps fades in busy middle life, to return, say,
in a sudden premonitory bout of insomnia. One of

the supreme secular meditations on death is Larkin's
Aubade:

> *. . . The sure extinction that we travel to*
> *And shall be lost in always. Not to be here,*
> *Not to be anywhere,*
> *And soon; nothing more terrible, nothing more true.*

We confront our mortality in private conversa-
tions, in the familiar consolations of religion – 'That
vast moth-eaten musical brocade,' thought Larkin,
'Created to pretend we never die.' And we experience
it as a creative tension, an enabling paradox in our
literature and art: what is depicted, loved, or cele-
brated cannot last, and the work must try to outlive
its creator. Larkin, after all, is now dead. Unless we
are a determined, well-organised suicide, we cannot
know the date of our demise, but we know the date
must fall within a certain window of biological pos-
sibility which, as we age, must progressively narrow
to its closing point.

Estimating the nature and timing of our *collective*
demise, not a lecture-roomful, but the end of civili-
sation, of the entire human project, is even less
certain – it might happen in the next hundred years,
or not happen in two thousand, or happen with
imperceptible slowness. The fossil records show us
that, overwhelmingly, most species are extinct. But

in the face of that unknowability, there has often flourished powerful certainty about the approaching end. Throughout recorded history people have mesmerised themselves with stories which predict the date and manner of our whole-scale destruction, often rendered meaningful by ideas of divine punishment and ultimate redemption; the end of life on earth, the end or last days, end time, the apocalypse.

Many of these stories are highly specific accounts of the future and are devoutly believed. Contemporary apocalyptic movements, Christian or Islamic, some violent, some not, all appear to share fantasies of a violent end, and they affect our politics profoundly. The apocalyptic mind can be demonising – that is to say there are other groups, other faiths, that it despises for worshipping false gods, and these believers of course will not be saved from the fires of hell.

And the apocalyptic mind tends to be totalitarian – that these are intact, all-encompassing ideas founded in longing and supernatural belief, immune to evidence or its lack, and well protected against the implications of fresh data. Consequently, moments of unintentional pathos, even comedy, arise – and perhaps something in our nature is revealed – as the future is constantly having to be rewritten, new anti-Christs, new Beasts, new Babylons, new Whores located, and the old appointments with doom and redemption quickly replaced by the next.

Not even a superficial student of the Christian apocalypse could afford to ignore the work of Norman Cohn. His magisterial *The Pursuit of the Millennium* was published sixty years ago and is a study of a variety of end-time movements that swept through northern Europe between the eleventh and sixteenth centuries. These sects, generally inspired by the symbolism in the Book of Revelation, typically led by a charismatic prophet who emerged from among the artisan class or from the dispossessed, were seized by the notion of an impending end, to be followed by the establishing of the Kingdom of God on earth. In preparation for this, it was believed necessary to slaughter Jews, priests and property owners. Fanatical rabbles, tens-of-thousands-strong, oppressed and often starving and homeless, roamed from town to town, full of wild hope and murderous intent. The authorities, church and lay, would put down these bands with great violence. A few years, or a generation later, with a new leader and faintly different emphasis, a new group would rise up. It is worth remembering that the impoverished mobs that trailed behind the knights of the first Crusades started their journeys by killing Jews in the thousands in the Upper Rhine area. These days, when Muslims of radical tendency pronounce against 'Jews and Crusaders', they should remember that both Jewry and Islam were victims of the Crusades.

What strikes the reader of Cohn's book are the common threads that run between medieval and contemporary apocalyptic thought. First, and in general, the resilience of the end-time forecasts – time and again, for 500 years, the date is proclaimed, nothing happens, and no one feels discouraged from setting another date. Second, the Book of Revelation spawned a literary tradition that kept alive in medieval Europe the fantasy, derived from the Judaic tradition, of divine election. Christians, too, could now be the Chosen People, the saved or the Elect, and no amount of official repression could smother the appeal of this notion to the unprivileged as well as the unbalanced. Third, there looms the figure of a mere man, apparently virtuous, risen to eminence, but in reality seductive and Satanic – he is the anti-Christ, and in the five centuries that Cohen surveys, the role is fulfilled by the Pope, just as it frequently is now.

Finally, there is the boundless adaptability, the undying appeal and fascination of the Book of Revelation itself, the central text of apocalyptic belief. When Christopher Columbus arrived in the Americas, making landfall in the Bahaman islands, he believed he had found, and had been fated to find, the Terrestrial Paradise promised in the Book of Revelation. He believed himself to be implicated in God's planning for the millennial kingdom on earth.

The scholar Daniel Wocjik quotes from Columbus's account of his first journey: 'God made me the messenger of the new heaven and the new earth of which he spoke in the Apocalypse of St John ... and he showed me the spot where to find it.'

Five centuries later, the United States, responsible for more than four-fifths of the world's scientific research and still a land of plenty, can show the world an abundance of opinion polls concerning its religious convictions. The litany will be familiar. A strong majority of Americans say they have never doubted the existence of God and are certain they will be called to answer for their sins. Over half are creationists who believe that the cosmos is 6,000 years old, and are certain that Jesus will return to judge the living and the dead within the next fifty years. In one survey, 12 per cent believed that life on earth has evolved through natural selection without the intervention of supernatural agency.

In general, belief in end-time biblical prophecy, in a world purified by catastrophe and then redeemed and made entirely Christian and free of conflict by the return of Jesus in our lifetime, is stronger in the United States than anywhere on the planet, and extends from marginal, ill-educated, economically deprived groups to college-educated people in the millions, through to governing elites, to the very summits of power. The social scientist J. W. Nelson

notes that apocalyptic ideas 'are as American as the hot dog'. Wojcik reminds us of the ripple of anxiety that ran round the world in April 1984 when President Reagan acknowledged that he was greatly interested in the biblical prophecy of imminent Armageddon.

To the secular mind, these survey figures have a titillating quality – one might think of them as a form of atheist's pornography. But one should retain a degree of scepticism. They vary enormously – one poll's 90 per cent is another's 53 per cent. From a respondent's point of view, what is to be gained by categorically denying the existence of God to a complete stranger with a clipboard? Those who tell pollsters they believe that the Bible is the literal word of God from which derive all proper moral precepts, are more likely to be thinking in general terms of love, compassion, and forgiveness rather than of the slave-owning, ethnic cleansing, infanticide and genocide urged at various times by the jealous God of the Old Testament.

Furthermore, the mind is capable of artful compartmentalisations; in one moment, a man might confidently believe in predictions of Armageddon in his lifetime, and in the next, he might pick up the phone to enquire about a savings fund for his grandchildren's college education or approve of long-term measures to slow global warming. Or he might even

vote Democrat, as do many Hispanic biblical literal-
ists. In Pennsylvania, Kansas and Ohio, the courts
have issued ringing rejections of Intelligent Design,
and voters have ejected creationists from school
boards. In the celebrated Dover case, Judge John
Jones the third, a Bush appointee, handed down a
judgment that was not only a scathing dismissal of
the prospect of supernatural ideas imported into
science classes, but was also an elegant, stirring
summary of the project of science in general, and of
natural selection in particular, and a sturdy endorse-
ment of the rationalist, Enlightenment values that
underlie the Constitution.

Still, the Book of Revelation, the final book of the
Bible, and perhaps its most bizarre, certainly one of
its most lurid, remains important in the United
States, just as it once was in medieval Europe. The
book is also known as the Apocalypse – and we
should be clear about the meaning of this word,
which is derived from the Greek word for revelation.
Apocalypse, which has become synonymous with
'catastrophe', actually refers to the literary form in
which an individual describes what has been revealed
to him by a supernatural being. There was a long
Jewish tradition of prophecy, and there were hun-
dreds if not thousands of seers like John of Patmos
between the second century BC and the first century
AD. Many other Christian apocalypses were deprived

of canonical authority in the second century AD. Revelation most likely survived because its author was confused with John, the Beloved Disciple. It is interesting to speculate how different medieval European history, and indeed the history of religion in Europe and the United States, would have been if the Book of Revelation had also failed, as it nearly did, to be retained in the Bible we now know.

THE SCHOLARLY CONSENSUS dates Revelation to 95 or 96 AD. Little is known of its author beyond the fact that he is certainly not the apostle John. The occasion of writing appears to be the persecution of Christians under the Roman emperor Domitian. This was only a generation before the Romans sacked the Second Temple in Jerusalem and is therefore identified with the Babylonians who had destroyed the First Temple centuries earlier. The general purpose quite likely was to give hope and consolation to the faithful in the certainty that their tribulations would end, that the Kingdom of God would prevail. Ever since the influential twelfth-century historian, Joachim of Fiore, Revelation has been seen, within various traditions of gathering complexity and divergence, as an overview of human history whose last stage we are now in; alternatively, and this is especially relevant to the postwar United States, as an account purely of those last days. For centuries,

within the Protestant tradition, the anti-Christ was identified with the Pope, or with the Catholic Church in general. In recent decades, the honour has been bestowed on the Soviet Union, the European Union, or secularism and atheists. For many millennial dispensationalists, international peacemakers, who risk delaying the final struggle by sowing concord among nations – the United Nations, along with the World Council of Churches, have been seen as Satanic forces.

THE CAST OR contents of Revelation in its contemporary representations has all the colourful gaudiness of a children's computer fantasy game – earthquakes and fires, thundering horses and their riders, angels blasting away on trumpets, magic vials, Jezebel, a red dragon and other mythical beasts, and a scarlet woman. Another familiar aspect is the potency of numbers – seven each of seals, heads of beasts, candlesticks, stars, lamps, trumpets, angels, and vials; then four riders, four beasts with seven heads, ten horns, ten crowns, four-and-twenty elders, twelve tribes with twelve thousand members . . . and finally, most resonantly, spawning nineteen centuries of dark tomfoolery, 'Here is wisdom. Let him that hath understanding count the number of the beast; for it is the number of a man; and his number is six hundred, three score and six.' To many minds, 666 bristles with significance. The Internet is stuffed

with tremulous speculation about supermarket barcodes, implanted chips, numerical codes for the names of world leaders. However, the oldest known record of this famous verse, from the Oxyrhynchus site, gives the number as 616, as does the Zurich Bible. I have the impression that any number would do. One senses in the arithmetic of prophecy the yearnings of a systematising mind, bereft of the experimental scientific underpinnings that were to give such human tendencies their rich expression many centuries later. Astrology gives a similar impression of numerical obsession operating within a senseless void.

But Revelation has endured in an age of technology and scepticism. Not many works of literature, not even the *Odyssey* of Homer, can boast such wide appeal over such an expanse of time. One celebrated case of this rugged durability is that of William Miller, the nineteenth-century farmer who became a prophet and made a set of intricate calculations, based on a line in verse 14 of the Book of Daniel: 'unto two thousand and three hundred days; then shall the sanctuary be cleansed.' Counting for various reasons this utterance to date from 457 BC, and understanding one prophetic day to be the equivalent of a year, Miller came to the conclusion that the last of days would occur in 1843. Some of Miller's followers refined the calculations further to 22 October.

After nothing happened on that day, the year was quickly revised to 1844, to take into account the year zero. The faithful Millerites gathered in their thousands to wait. One may not share the beliefs, but still understand the mortifying disenchantment. One eyewitness wrote,

> [We] confidently expected to see Jesus Christ and all the holy angels with him ... and that our trials and sufferings with our earthly pilgrimage would close and we should be caught up to meet our coming Lord ... and thus we looked for our coming Lord until the bell tolled twelve at midnight. The day had then passed and our disappointment became a certainty. Our fondest hopes and expectations were blasted, and such a spirit of weeping came over us as I never experienced before. It seemed that the loss of all our earthly friends could have been no comparison. We wept, and wept, till the day dawn.

One means of dealing with the disillusionment was to give it a title – the Great Disappointment – duly capitalised. More importantly, according to Kenneth Newport's account of the Waco siege, the very next day after the Disappointment, one Millerite leader in Port Gibson, New York, by the name of Hiram Edson had a vision as he walked along, a

sudden revelation that 'the cleansing of the sanctuary' referred to events not on earth, but in heaven. Jesus had taken his place in the heavenly holy of holies. The date had been right all along: it was simply the *place* they had got wrong. This 'masterstroke', as Newport calls it, this 'theological lifeline', removed the whole affair into a realm immune to disproof. The Great Disappointment was explained, and many Millerites were drawn, with hope still strong in their hearts, into the beginnings of the Seventh Day Adventist movement – which was to become one of the most successful churches in the United States.

Note the connections between this tendency and the medieval sects that Cohn describes – the strong emphasis on the Book of Revelation, the looming proximity of the end, the strict division between the faithful remnant who keep the Sabbath and those who join the ranks of the 'fallen', of the anti-Christ, identified with the Pope whose title, Vicarius Filii Dei (vicar of the son of God), apparently has a numerical value of 666.

I mention Hiram Edson's morning-after masterstroke to illustrate the resilience of end-time thought. For centuries, it has regarded the end as 'soon' – if not next week, then within a year or two. The end has not come, and yet no one is discomfited for long. New prophets, and soon, a new generation, set about the

calculations, and always manage to find the end looming within their own lifetime. The million-sellers like Hal Lindsey predicted the end of the world all through the seventies, eighties and nineties – and today, business has never been better. There is a hunger for this news, and perhaps we glimpse here something in our nature, something of our deeply held notions of time, and our own insignificance against the intimidating vastness of eternity or the age of the universe – on the human scale there is little difference. We have need of a plot, a narrative to shore up our irrelevance in the flow of things.

In *The Sense of an Ending*, Frank Kermode suggests that the enduring quality, the vitality of the Book of Revelation suggests a 'consonance with our more naïve requirements of fiction'. We are born, as we will die, in the middle of things, in the 'middest'. To make sense of our span, we need what he calls 'fictive concords with origins and ends. "The End", in the grand sense, as we imagine it, will reflect our irreducibly intermediary expectations.' What could grant us more meaning against the abyss of time than to identify our own personal demise with the purifying annihilation of all that is? Kermode quotes Wallace Stevens: 'it is one of the peculiarities of the imagination that it is always at the end of an era'. Even our notions of decadence contain the hopes of renewal; the religious-minded, as well as the most

secular, looked on the transition to the year 2000 as inescapably significant, even if all the atheists did was to party a little harder. It was inevitably a transition, the passing of an old age into the new – and who is to say now that Osama bin Laden did not disappoint, whether we mourned at the dawn of the new millennium with the bereaved among the ruins of lower Manhattan, or danced for joy, as some did, in East Jerusalem?

Islamic eschatology from its very beginnings embraced the necessity of violently conquering the world and gathering up souls to the faith before the expected hour of judgment – a notion that has risen and fallen over the centuries, but in past decades has received new impetus from Islamist revivalist movements. It is partly a mirror image of the Protestant Christian tradition (a world made entirely Islamic, with Jesus as Muhammad's lieutenant), partly a fantasy of the inevitable return of 'sacred space', the Caliphate, that includes most of Spain, parts of France, the entire Middle East, right up to the borders of China. As with the Christian scheme, Islam foretells of the destruction or conversion of the Jews.

PROPHECY BELIEF IN Judaism, the original source for both the Islamic and Christian eschatologies, is surprisingly weaker – perhaps a certain irony in the relationship between Jews and their god is unfriendly

to end-time belief, but it lives on vigorously enough in the Lubavitch movement and various Israeli settler groups, and of course is centrally concerned with divine entitlement to disputed lands.

WE SHOULD ADD to the mix more recent secular apocalyptic beliefs – the certainty that the world is inevitably doomed through nuclear exchange, viral epidemics, meteorites, population growth or environmental degradation. Where these calamities are posed as mere possibilities in an open-ended future that might be headed off by wise human agency, we cannot consider them as apocalyptic. They are minatory, they are calls to action. But when they are presented as unavoidable outcomes driven by ineluctable forces of history or innate human failings, they share much with their religious counterparts – though they lack the demonising, cleansing, redemptive aspects, and are without the kind of supervision of a supernatural entity that might give benign meaning and purpose to a mass extinction. Clearly, fatalism is common to both camps, and both, reasonably enough, are much concerned with a nuclear holocaust, which to the prophetic believers illuminates in retrospect biblical passages that once seemed obscure. Hal Lindsey, pre-eminent among the popularisers of American apocalyptic thought, writes,

Zechariah 14:12 predicts that 'their flesh will be consumed from their bones, their eyes burned out of their sockets, and their tongues consumed out of their mouths while they stand on their feet'. For hundreds of years students of Bible prophecy have wondered what kind of plague could produce such instant ravaging of humans while still on their feet. Until the event of the atomic bomb such a thing was not humanly possible. But now everything Zecheriah predicted could come true in a thermonuclear exchange!

Two other movements, now mercifully defeated or collapsed, provide a further connection between religious and secular apocalypse – so concluded Norman Cohn in the closing pages of *The Pursuit of the Millennium*. The genocidal tendency among the apocalyptic medieval movements faded somewhat after 1500. Vigorous end-time belief continued, of course, in the Puritan and Calvinist movements, the Millerites, as we have seen, and in the American Great Awakening, Mormonism, Jehovah's Witnesses and the Adventist movement.

The murderous tradition, however, did not die away completely. It survived the passing of centuries in various sects, various outrages, to emerge in the European twentieth century transformed, revitalised, secularised, but still recognisable in

what Cohn depicts as the essence of apocalyptic thinking:

> the tense expectation of a final, decisive struggle in which a world tyranny will be overthrown by a "chosen people" and through which the world will be renewed and history brought to its consummation. The will of god was transformed in the twentieth century into the will of history, but the essential demand remained, as it still does today – to purify the world by destroying the agents of corruption.

The dark reveries of Nazism about the Jews shared much with the murderous anti-Semitic demonology of medieval times. An important additional element, imported from Russia, was *The Protocols of the Elders of Zion*, the 1905 Tsarist police forgery, elevated by Hitler and others into a racist ideology. (It's interesting to note how the *Protocols* has re-emerged as a central text for Islamists, frequently quoted on websites, and sold in street book stalls across the Middle East.) The Third Reich and its dream of a thousand-year rule was derived, in a form of secular millennial usurpation, directly from Revelation. Cohn draws our attention to the apocalyptic language of *Mein Kampf*:

> If our people . . . fall victims to these Jewish tyrants of the nations with their lust for blood and gold, the

whole earth will sink down ... if Germany frees itself from this embrace, this greatest of dangers for the peoples can be regarded as vanquished for all the earth.

In Marxism in its Soviet form, Cohn also found a continuation of the old millenarian tradition of prophecy, of the final violent struggle to eliminate the agents of corruption – this time it is the bourgeoisie who will be vanquished by the proletariat in order to enable the withering away of the state and usher in the peaceable kingdom. 'The kulak ... is prepared to strangle and massacre hundreds of thousands of workers ... Ruthless war must be waged on the kulaks! Death to them!' Thus spoke Lenin, and his word, like Hitler's, became deed.

Thirty years ago, we might have been able to convince ourselves that contemporary religious apocalyptic thought was a harmless remnant of a more credulous, superstitious, pre-scientific age, now safely behind us. But today prophecy belief, particularly within the Christian and Islamic traditions, is a force in our contemporary history, a medieval engine driving our modern moral, geo-political and military concerns. Various gods – and they are certainly not one and the same god – who in the past directly addressed Abraham, Paul, or Muhammad, among

others, now indirectly address us through the internet and television news. These different gods have wound themselves inextricably around our political differences.

Our secular and scientific culture has not replaced or barely challenged these mutually incompatible, supernatural thought systems. Scientific method, scepticism, or rationality in general, has yet to find an overarching narrative of sufficient power, simplicity and wide appeal to compete with the old stories that give meaning to people's lives. Natural selection is a powerful, elegant and economic explicator of life on earth in all its diversity, and perhaps it contains the seeds of a rival creation myth that would have the added power of being true – but it awaits its inspired synthesiser, its poet, its Milton. E. O. Wilson has suggested an ethics divorced from religion, and derived instead from what he calls biophilia, our innate and profound connection to our natural environment – but one man alone cannot make a moral system. Climate science may speak of rising sea levels and global temperatures, with figures that it refines in line with new data, but on the human future it cannot compete with the luridness and, above all, with the meaningfulness of the prophecies in the Book of Daniel, or Revelation. Reason and myth remain uneasy bedfellows.

Rather than presenting a challenge, science has in

obvious ways strengthened apocalyptic thinking. It
has provided us with the means to destroy ourselves
and our civilisation completely in less than a couple
of hours, or to spread a fatal virus around the globe
in a couple of days. And our spiraling technologies of
destruction and their ever-greater availability have
raised the possibility that true believers, with all
their unworldly passion, their prayerful longing for
the end-times to begin, could help nudge the ancient
prophecies towards fulfillment. Daniel Wojcik, in his
study of apocalyptic thought in America, quotes a
letter by the singer Pat Boone addressed to fellow
Christians. All-out nuclear war is what he appears to
have had in mind.

> My guess is that there isn't a thoughtful Christian
> alive who doesn't believe we are living at the end of
> history. I don't know how that makes you feel, but it
> gets me pretty excited. Just think about actually see-
> ing, as the apostle Paul wrote it, the Lord Himself
> descending from heaven with a shout! Wow! And the
> signs that it's about to happen are everywhere.

If the possibility of a willed nuclear catastrophe
appears too pessimistic or extravagant, or hilarious,
consider the case of another individual, remote from
Pat Boone – former President Ahmadinejad of Iran.
His much reported remark about wiping Israel off

the face of the earth may have been mere bluster of the kind you could hear any Friday or Sunday in a thousand mosques and churches around the world. But this posturing, coupled with his nuclear ambitions, become more worrying when set in the context of his end-time beliefs. In Jamkaran, a village not far from the holy city of Qom, a small mosque underwent a 20-million-dollar expansion that was driven forward by Ahmadinejad's office during his incumbency. Within the Shi'ite apocalyptic tradition, the Twelfth Imam, the Mahdi, who disappeared in the ninth century, is expected to reappear in a well behind the mosque. His re-emergence will signify the beginning of the end days. He will lead the battle against the Dajjal, the Islamic version of the anti-Christ, and, with Jesus as his follower, will establish the global Dar el Salam, the dominion of peace, under Islam. Ahmadinejad extended the mosque to receive the Mahdi. Pilgrims by the thousands immediately visited the shrine, for the President reportedly told his cabinet that he expected the visitation within two years.

Or again, consider the celebrated case of the red heifer, or calf. On the Temple Mount in Jerusalem, the end-time stories of Judaism, Christianity, and Islam converge in both interlocking and mutually exclusive ways that are potentially explosive – they form incidentally the material for the American novelist Robert

Stone's fine novel, *Damascus Gate*. What is bitterly contested is not only the past and present, but the future. It is hardly possible to do justice in summary to the complex eschatologies that jostle on this thirty-five-acre patch of land. The stories themselves are familiar. For the Jews, the Mount – the biblical Mount Moriah – is the site of the First Temple, destroyed by Nebuchadnezzar in 586 BC, and of the Second Temple destroyed by the Romans in 70 AD. According to tradition, and of particular interest to various controversial groups, including the Temple Institute, the Messiah, when he comes at last, will occupy the Third Temple. But that cannot be built, and therefore the Messiah will not come, without the sacrifice of a perfectly unblemished red calf.

For Muslims, the Mount is the site of the Dome of the Rock, built over the location of the two temples and enclosing the very spot from which Muhammad departed on his Night Journey to heaven – leaving as he stepped upwards a revered footprint in the rock. In the prophetic tradition, the Dajjal will be a Jew who leads a devastating war against Islam. Attempts to bless a foundation stone of a new temple are seen as highly provocative, for this implies the destruction of the mosque. The symbolism surrounding Ariel Sharon's visit to the Mount in September 2000 remains a matter of profoundly different interpretation by Muslims and Jews. And if lives were not at

stake, the Christian fundamentalist contribution to this volatile mix would seem amusingly cynical. These prophetic believers are certain that Jesus will return at the height of the battle of Armageddon, but his thousand-year reign, which will ensure the conversion of Jews and Muslims to Christianity, or their extinction, cannot begin until the Third Temple is built.

And so it came about that a cattle-breeding operation emerged in Israel with the help of Texan Christian fundamentalist ranchers to promote the birth of the perfect, unspotted red calf, and thereby, we have to assume, bring the end days a little closer. In 1997 there was great excitement, as well as press mockery, when one promising candidate appeared. Months later, this cherished young cow nicked its rump on a barbed wire fence, causing white hairs to grow at the site of the wound and earning instant disqualification. Another red calf appeared in 2002 to general acclaim, and then again, later disappointment. In the tight squeeze of history, religion and politics that surrounds the Temple Mount, the calf is a minor item. But the search for it, and the hope and longing that surround it, illustrate the dangerous tendency among prophetic believers to bring on the cataclysm that they think will lead to a form of paradise on earth. The reluctance of the current US administration to pursue an even-handed policy

towards a peace settlement in the Israel-Palestine dispute may owe as much to the pressures of nationalist Jewish groups as to the eschatology of Christian fundamentalists.

Periods of uncertainty in human history, of rapid, bewildering change and of social unrest appear to give these old stories greater weight. It does not need a novelist to tell you that where a narrative has a beginning, it needs an end. Where there is a creation myth, there must be a final chapter. Where a god makes the world, it remains in his power to unmake it. When human weakness or wickedness is apparent, there will be guilty fantasies of supernatural retribution. When people are profoundly frustrated, either materially or spiritually, there will be dreams of the perfect society where all conflicts are resolved and all needs are met.

That much we can understand or politely pretend to understand. But the problem of fatalism remains. In a nuclear age, and in an age of serious environmental degradation, apocalyptic belief creates a serious second-order danger. The precarious logic of self-interest that saw us through the Cold War would collapse if the leaders of one nuclear state came to welcome, or ceased to fear, mass death. These words of Ayatollah Khomeini are quoted approvingly in an Iranian eleventh grade textbook: 'Either we shake one another's hands in joy at the victory of Islam in

the world, or all of us will turn to eternal life and martyrdom. In both cases, victory and success are ours.' If I were a believer, I think I would prefer to be in Jesus's camp. He is reported by Matthew to have said, 'No one knows about that day or hour, not even the angels in heaven, nor the Son, but only the Father.'

Even a sceptic can find in the historical accumulation of religious expression joy, fear, love and above all, seriousness. I return to Philip Larkin – an atheist who also knew the moment and the nature of transcendence. In 'Church Going' he writes:

> A serious house on serious earth it is,
> In whose blent air all our compulsions meet,
> Are recognised, and robed as destinies.

And how could one be more serious than the writer of this prayer for the interment of the dead, from *The Book of Common Prayer*, an incantation of bleak, existential beauty, even more so in its beautiful setting by Henry Purcell: 'Man that is born of a woman hath but a short time to live, and is full of misery. He cometh up, and is cut down, like a flower; he fleeth as it were a shadow, and never continueth in one stay.'

Ultimately, apocalyptic belief is a function of faith – that luminous inner conviction that needs no recourse to evidence. It is customary to pose against

immoveable faith the engines of reason, but in this instance I would prefer that delightful human impulse – curiosity, the hallmark of mental freedom. Organised religion has always had – and I put this mildly – a troubled relationship with curiosity. Islam's distrust, at least in the past 200 years, is best expressed by its attitude to those whose faith falls away, to apostates who are drawn to other religions or to none at all. In recent times, in 1975, the mufti of Saudi Arabia, Bin Baz, in a fatwa, quoted by Shmuel Bar, ruled as followed: 'Those who claim that the earth is round and moving around the Sun are apostates and their blood can be shed and their property can be taken in the name of God.' Bin Baz rescinded this judgment ten years later. Mainstream Islam routinely prescribes punishment for apostates that ranges from ostracism to beatings to death. To enter one of the many websites where Muslim apostates anonymously exchange views is to encounter a world of brave and terrified men and women who have succumbed to their disaffection and intellectual curiosity.

And Christians should not feel smug. The first commandment – on pain of death if we were to take the matter literally – is 'Thou shalt have no other gods before me.' In the fourth century, St Augustine put the matter well for Christianity, and his view prevailed for a long time: 'There is another form of

temptation, even more fraught with danger. This is the disease of curiosity. It is this which drives us to try and discover the secrets of nature which are beyond our understanding, which can avail us nothing, and which man should not wish to learn.'

And yet it is curiosity, scientific curiosity, that has delivered us genuine, testable knowledge of the world and contributed to our understanding of our place within it and of our nature and condition. This knowledge has a beauty of its own, and it can be terrifying. We are barely beginning to grasp the implications of what we have relatively recently learned. And what exactly have we learned? I draw here from and adapt a Stephen Pinker essay on his ideal of a university: among other things we have learned that our planet is a minute speck in an inconceivably vast cosmos; that our species has existed for a tiny fraction of the history of the earth; that humans are primates; that the mind is the activity of an organ that runs by physiological processes; that there are methods for ascertaining the truth that can force us to conclusions which violate common sense, sometimes radically, so at scales very large and very small; that precious and widely held beliefs, when subjected to empirical tests, are often cruelly falsified; that we cannot create energy or use it without loss.

As things stand, after more than a century of research in a number of fields, we have no evidence

at all that the future can be predicted. Better to look directly to the past, to its junkyard of unrealised futures, for it is curiosity about history that should give end-time believers reasonable pause when they reflect that they stand on a continuum, a long and unvarying thousand-year tradition that has fantasised imminent salvation for themselves and perdition for the rest. On one of the countless end-time/rapture sites that litter the Web, there is a section devoted to Frequently Asked Questions. One is: When the Lord comes, what will happen to the children of other faiths? The answer is staunch: 'Ungodly parents only bring judgment to their children.' In the light of this, one might conclude that end-time faith is probably immune to the lessons of history.

If we do destroy ourselves, we can be sure that the general reaction will be terror, and grief at the pointlessness of it all, rather than rapture. Within living memory we have come very close to extinguishing our civilisation when, in October 1962, Soviet ships carrying nuclear warheads to installations in Cuba confronted a blockade by the US Navy, and the world waited to discover whether Nikita Khrushchev would order his convoy home. It is remarkable how little of that terrifying event survives in public memory, in modern folklore. In the vast literature the Cuban Missile Crisis has spawned – military,

political, diplomatic – there is very little on its effect at the time on ordinary lives, in homes, schools and the workplace, on the fear and widespread numb incomprehension in the population at large. That fear has not passed into the national narrative, here or anywhere else, as vividly as one might expect. As Spencer Weart put it, 'When the crisis ended, most people turned their attention away as swiftly as a child who lifts up a rock, sees something slimy underneath, and drops the rock back.' Perhaps the assassination of President Kennedy the following year helped obscure the folk memory of the Missile Crisis. His murder in Dallas became a marker in the history of instantaneous globalized news transmission – a huge proportion of the world's population seemed to be able to recall where they were when they heard the news. Conflating these two events, Christopher Hitchens opened an essay on the Cuban Missile Crisis with the words – 'Like everyone else of my genera-tion, I can remember exactly where I was standing and what I was doing on the day that President John Fitzgerald Kennedy nearly killed me.' Heaven did not beckon during those tense hours of the crisis. Instead, as Hitchens observes, 'It brought the world to the best view it has had yet of the gates of hell.'

I began with the idea of photography as the inven-tory of mortality, and I will end with a photograph of a group death. It shows fierce flames and smoke

rising from a building in Waco, Texas, at the end of a fifty-one-day siege in 1993. The group inside was the Branch Davidians, an offshoot of the Seventh Day Adventists. Its leader, David Koresh, was a man steeped in biblical, end-time theology, convinced that America was Babylon, the agent of Satan, arriving in the form of the Bureau of Alcohol, Tobacco, and Firearms and the FBI to destroy the Sabbath-keeping remnant who would emerge from the cleansing, suicidal fire to witness the dawn of a new Kingdom. Here is Susan Sontag's 'posthumous irony' indeed, as medieval Europe recreated itself in the form of a charismatic man, a messiah, a messenger of God, the bearer of the perfect truth, who exercised sexual power over his female followers and persuaded them to bear his children in order to begin a 'Davidian' line. In that grim inferno, children, their mothers and other followers died. Even more died two years later when Timothy McVeigh, exacting revenge against the government for its attack on Waco, committed his slaughter in Oklahoma City. It is not for nothing that one of the symptoms in a developing psychosis, noted and described by psychiatrists, is 'religiosity'.

Have we really reached a stage in public affairs when it is no longer too obvious to say that all the evidence of the past and all the promptings of our precious rationality suggest that our future is not

fixed? We have no reason to believe that there are dates inscribed in heaven or hell. We may yet destroy ourselves; we might scrape through. Confronting that uncertainty is the obligation of our maturity and our only spur to wise action. The believers should know in their hearts by now that, even if they are right and there actually is a benign and watchful personal God, he is, as all the daily tragedies, all the dying children attest, a reluctant intervener. The rest of us, in the absence of any evidence to the contrary, know that it is highly improbable that there is anyone up there at all. Either way, in this case it hardly matters who is wrong – there will be no one to save us but ourselves.

Payne Lecture, Stanford University, 2007

5

Solar

IT WAS SOOTHING, mostly, to take once a week the grubby morning train from Paddington to Reading, to be met at that Victorian station squashed in among the stubby tower blocks and be driven a few miles in a prototype Prius to the Centre by one of the indistinguishable ponytails. Leaving home, Beard was a tensed one-note vibrating string, whose oscillations diminished the further he left his home behind and the closer he approached the expensive perimeter fence. The vibrations came to rest as he acknowledged with raised forefinger the friendly salute of the security guards – how they loved a supremo! – and swept by, under the raised red-and-white barrier. Braby generally came out to meet him and even, with barely a touch of mandarin irony, held open the car door, for this was no cuckold arriving, but the

distinguished visitor, the Chief, counted on to speak up for the place in the press, encourage the energy industries to take an interest, and squeeze another quarter-million from the blustering Minister.

The two men took coffee together at the start of the day. Progress and delays were listed and Beard noted whatever was required of him, then toured the site. In an off-the-cuff way he had proposed right at the start that it would be easier to procure more funds if he could claim for the Centre a single eye-catching project that would be comprehensible to the taxpayer and the media. And so the WUDU had been launched, a Wind turbine for Urban Domestic Use, a gizmo the householder could install on his rooftop to generate enough power to make a significant reduction in his electricity bill. On town roofs the wind did not blow smoothly from one direction the way it did on high towers in open country, so the physicists and engineers were asked to research an optimal design for wind-turbine blades in turbulent conditions. Beard had leaned on an old friend at the Royal Aircraft Establishment at Farnborough for access to a wind tunnel, but first there were some intricate maths and aerodynamics to investigate, some sub-branch of chaos theory that he himself had little patience with. His interest in technology was even weaker than his interest in climate science. He had thought it would be a matter of settling the

maths for the design, building three or four proto-types and testing them in the tunnel. But more people had to be hired as related issues wormed their way onto the agenda: vibration, noise, cost, height, wind shear, gyroscopic precession, cyclic stress, roof strength, materials, gearing, efficiency, phasing with the grid, planning permissions. What had seemed a simple wheeze had turned into a monster that was eating up all the attention and resources of the half-built Centre. And it was too late to turn back.

Beard preferred to go around alone to witness guiltily the consequences of his casual proposal. By the early summer of 2000 the post-docs each had a small cubicle of their own. Breaking up the group had helped, as had the nameplates on the door, but Beard put it down mostly to his own perceptiveness, the way each of the young men, after seven or eight months, was drifting into focus. He had made a mere half-dozen trips from Reading station in the Prius when, looking up from a speech he was to give that night in Oxford, he realised that, of course, the same driver had picked him up each time. He was one of the two who actually had a ponytail, a tall, thin-faced lad with a mouth overstuffed with large teeth and goofy smile. He came from outside Swaffham in Norfolk, Beard learned in this, his first focused con-versation, and had been at Imperial, then Cambridge, then two years at Caltech in Pasadena, and none of

these fabled places had diluted the pure inflections of his rural accent and its innocent swerves and dips and persistent rising line, suggestive to Beard of hedgerows and hayricks. His name was Tom Aldous. He told the Chief in that first chat that he had applied to work at the Centre because he thought the planet was in danger, and that his background in particle physics might be of some use, and that when he saw that Beard himself was going to lead the team, Beard of the Beard–Einstein Conflation, he, Tom Aldous, excitedly assumed that the Centre would have as its prime concern solar energy, particularly artificial photosynthesis and what he called nano-solar, about which he was convinced . . .

'Solar energy?' Beard said mildly. He knew perfectly well what was meant, but still, the term had a dubious halo of meaning, an invocation of New Age Druids in robes dancing round Stonehenge at Midsummer's dusk. He also distrusted anyone who routinely referred to 'the planet' as proof of thinking big.

'Yes!' Aldous smiled with his many teeth into the rear-view mirror. It would not have occurred to him that the Chief was not an expert in the field. 'It's all out there, waiting for us to understand how to use it, and when we do, we'll be amazed we ever thought of burning coal and oil and the like.'

Beard was intrigued by the way Aldous said 'loike'. It seemed to mock what he was trying to say. They

were going along a four-lane ring road with flower-
ing hawthorns in the central reservation uselessly
casting their scent at the passing traffic. The previ-
ous night, with no expectation of sleep, he had lain
on his bed in his dressing gown reading while she
stayed out all night. It was an unpublished bundle of
letters to various colleagues from Paul Dirac, a man
entirely claimed by science, bereft of small talk and
other human skills. At six forty-five, Beard had set
down the typescript and had gone to the bathroom
to shave. Sunlight was already sloping through the
front-garden birch and patterning the marble floor
beneath his toes. What a waste, a failure of good gov-
ernance, to have the sun so high so early in the day.
He could not bear to count, he thought as he took his
razor to the new sprouting hair between his eye-
brows to give himself a younger look, all the hours of
daylight he had ever missed in summer. But what
could he have done, what was there for any young
man at seven in the morning at any time of year,
beyond sleep or getting to work? Now his sleep defi-
cit stretched back weeks.

'Do you think we could ever get by,' he asked, sti-
fling a yawn, 'without coal and oil and gas?'

Aldous was taking them at a clip around a giant
roundabout as big and busy as a racing circuit, that
slung them centrifugally out upon a descending slip
road and down onto the motorway, into the redoubled

roar of onrushing vehicles, and trucks the size of five terraced houses whining in file towards Bristol at eighty-five miles per hour, and everyone else lining up to shoot past. Exactly so – how long could this go on? Beard, weak and tender from sleeplessness, felt belittled. The M4 demonstrated a passion for existence which he could no longer match. He was for the B-road, a cart track, a footpath. Shrinking inside his Harris tweed jacket, he listened to Tom Aldous, who spoke with the lilting confidence of a prize pupil providing the answers he thinks he knows his teacher wants.

'Coal and then oil have made us, but now we know, burning the stuff will ruin us. We need a different fuel or we fail, we sink. It's about another industrial revolution. And there's no way round it, the future is electricity and hydrogen, the only two energy carriers we know that are clean at the point of use.'

'So, more nuclear power.'

The boy took his eyes off the road to lock with Beard's in the mirror – but for too long, and the older man, tensing on the back seat, looked away to encourage the driver's gaze back on the mayhem outside.

'Dirty, dangerous, expensive. But you know, we've already got a nuclear power station up and running with a great safety record making clean energy converting hydrogen to helium at no cost, nicely situated

ninety-three million miles away. You know what I always think, Professor Beard? If an alien arrived on earth and saw all this sunlight, he'd be amazed to hear that we think we've got an energy problem. Photovoltaics! I read Einstein on it, I read you. The Conflation is brilliant. And God's greatest gift to us is surely this, that a photon striking a semiconductor releases an electron. The laws of physics are so benign, so generous. And get this. There's a guy in a forest in the rain and he's dying of thirst. He has an axe and he starts cutting down the trees to drink the sap. A mouthful in each tree. All around him is a wasteland, no wildlife, and he knows that thanks to him the forest is disappearing fast. So why doesn't he just open his mouth and drink the rain? Because he's brilliant at chopping down trees, he's always done things this way, and he thinks that people who advocate rain-drinking are weird. That rain is our sunlight, Professor Beard. It drenches our planet, drives our climate and its life. A sweet rain of photons, and all we have to do is hold out our cups! D'you know, I read this guy saying somewhere that less than an hour's worth of all the sunlight falling on the earth would satisfy the whole world's needs for a year.'

Unimpressed, Beard said, 'And what was this guy taking as his measure of solar irradiance?'

'One quarter of the solar constant.'

'Too optimistic. You'd need to halve that again.'

'My point stands, Professor Beard. Solar arrays on a tiny fraction of the world's deserts would give us all the power we need.'

The Norfolk lad's bucolic tone, so at odds with what he was saying, was beginning to aggravate Beard's raw condition. He said sullenly, 'If you could distribute it.'

'Yes. New DC lines! That's just money and effort. Worth it for the planet! For our future, Professor Beard!'

Beard snapped the pages of his speech to indicate that the conversation was at a close. The essence of a crank was, firstly, to believe that all the world's problems could be reduced to one, and be solved. And secondly, to go on about it non-stop.

But Tom Aldous was not done with him yet. As they arrived at the Centre and the gates were raised, he said, as though there had been no break in the discussion, 'That's why, I mean, no disrespect, that's why I think we're wasting our time with this micro wind-power stuff. The technology's already good enough. The government just needs to make it attractive to people – it's stroke-of-the-pen stuff, the market will do the rest. There's so much money to be made. But solar – cutting-edge artificial photosynthesis – there's great basic research to do on the nanotechnology. Professor, it could be us!'

Aldous was holding open the door and Beard was

climbing wearily out. He said, 'Thank you for your thoughts. But really, you should learn to keep your eyes on the road.' And he turned away to shake Braby's hand.

On his weekly round, therefore, he hoped to avoid running into Aldous alone, for the young man was always trying to convince him of photovoltaics, or his quantum explanation of photovoltaics, or to oppress him generally with friendliness and enthusiasm, and seemed oblivious to Beard's surliness whenever he repeated the case for dropping WUDU. Of course it ought to be abandoned, when it was devouring nearly all the budget and growing in complication as it diminished in interest. But it had been Beard's idea, and reversing it would be a personal disaster. So he was coming to dislike this young man, his big-boned goofy face and flaring nostrils, his ponytail, his wrist bracelet of grubby red and green string intertwined, his holier-than-thou diet of salad and yoghurt in the canteen, his habit of bringing his tray over unasked and sitting as close as possible to the Chief, who could only be depressed to learn that Aldous had boxed for Norfolk in the county championships, had rowed for his college at Cambridge, had come seventh in a San Francisco marathon. There were novels Aldous wanted him to read – novels! – and developments in contemporary music he thought Beard should be aware of, and movies that were of

particular relevance, documentaries about climate change which Aldous had seen at least twice but would happily see again if there was a chance of making the Chief sit through them too. Aldous had a mind that was designed, through the medium of a Norfolk accent, to offer tireless advice, make recommendations, urge changes, or express enthusiasm for some journey or holiday or book or vitamin, which itself was a form of exhortation. Nothing eroded Beard's goodwill more than to hear again that he must spend a month in the Vale of Swat.

From Solar, 2010

6

Enduring Love

I LEFT HIM waiting in the front seat while I took some paper and went back into the trees, and used my heel to scrape a shallow trench. While I crouched there with my pants around my ankles, I tried to soothe myself by parting the crackly old leaves and scooping up a handful of soil. Some people find their long perspectives in the stars and galaxies; I prefer the earth-bound scale of the biological. I brought my palm close to my face and peered over my glasses. In the rich black crumbly mulch I saw two black ants: a springtail, and a dark red worm-like creature with a score of pale brown legs. These were the rumbling giants of this lower world, for not far below the threshold of visibility was the seething world of the roundworms – the scavengers and the predators who fed on them, and even these were giants relative to the inhabitants of

the microscopic realm, the parasitic fungi and the bacteria – perhaps ten million of them in this handful of soil. The blind compulsion of these organisms to consume and excrete made possible the richness of the soil, and therefore the plants, the trees, and the creatures that lived among them, whose number had once included ourselves. What I thought might calm me was the reminder that, for all our concerns, we were still part of this natural dependency – for the animals that we ate grazed the plants which, like our vegetables and fruits, were nourished by the soil formed by these organisms. But even as I squatted to enrich the forest floor, I could not believe in the primary significance of these grand cycles. Just beyond the oxygen-exhaling trees stood my poison-exuding vehicle, inside which was my gun, and thirty-five miles down teeming roads was the enormous city on whose northern side was my apartment where a madman was waiting, and my threatened loved one. What, in this description, was necessary to the carbon cycle, or the fixing of nitrogen? We were no longer in the great chain. It was our own complexity that had expelled us from the Garden. We were in a mess of our own unmaking.

I stood and buckled my belt and then, with the diligence of a household cat, kicked the soil back into my trench.

From Enduring Love, 1998

Machines Like Me

HE STOOD BEFORE me, perfectly still in the gloom of the winter's afternoon. The debris of the packaging that had protected him was still piled around his feet. He emerged from it like Botticelli's Venus rising from her shell. Through the north-facing window, the diminishing light picked out the outlines of just one half of his form, one side of his noble face. The only sounds were the friendly murmur of the fridge and a muted drone of traffic. I had a sense then of his loneliness, settling like a weight around his muscular shoulders. He had woken to find himself in a dingy kitchen, in London SW9 in the late twentieth century, without friends, without a past or any sense of his future. He truly was alone. All the other Adams and Eves were spread about the world with their owners, though seven Eves were said to be concentrated in Riyadh.

As I reached for the light switch I said, 'How are you feeling?' He looked away to consider his reply. 'I don't feel right.'

This time his tone was flat. It seemed my question had lowered his spirits. But within such microprocessors, what spirits?

'What's wrong?'

'I don't have any clothes. And—'

'I'll get you some. What else?'

'This wire. If I pull it out it will hurt.'

'I'll do it and it won't hurt.'

But I didn't move immediately. In full electric light I was able to observe his expression, which barely shifted when he spoke. It was not an artificial face I saw, but the mask of a poker player. Without the lifeblood of a personality, he had little to express. He was running on some form of default program that would serve him until the downloads were complete. He had movements, phrases, routines that gave him a veneer of plausibility. Minimally, he knew what to do, but little else. Like a man with a shocking hangover.

I could admit it to myself now – I was fearful of him and reluctant to go closer. Also, I was absorbing the implications of his last word. Adam only had to behave as though he felt pain and I would be obliged to believe him, respond to him as if he did. Too difficult not to. Too starkly pitched against the drift of

human sympathies. At the same time I couldn't believe he was capable of being hurt, or of having feelings, or of any sentience at all. And yet I had asked him how he felt. His reply had been appropriate, and so too my offer to bring him clothes. And I believed none of it. I was playing a computer game. But a real game, as real as social life, the proof of which was my heart's refusal to settle and the dryness in my mouth.

* * *

I REMAINED IN the kitchen, in an old leather armchair, with a balloon glass of Moldovan white. There was much pleasure in following a line of thought without opposition. I was hardly the first to think it, but one could see the history of human self-regard as a series of demotions tending to extinction. Once we sat enthroned at the centre of the universe, with sun and planets, the entire observable world, turning around us in an ageless dance of worship. Then, in defiance of the priests, heartless astronomy reduced us to an orbiting planet around the sun, just one among other rocks. But still, we stood apart, brilliantly unique, appointed by the creator to be lords of everything that lived. Then biology confirmed that we were at one with the rest, sharing common ancestry with bacteria, pansies, trout and sheep. In the early twentieth century came deeper

exile into darkness when the immensity of the universe was revealed and even the sun became one among billions in our galaxy, among billions of galaxies. Finally, in consciousness, our last redoubt, we were probably correct to believe that we had more of it than any creature on earth. But the mind that had once rebelled against the gods was about to dethrone itself by way of its own fabulous reach. In the compressed version, we would devise a machine a little cleverer than ourselves, then set that machine to invent another that lay beyond our comprehension. What need then of us?

* * *

IT WAS MY mind's eyes, or my heart's, that watched as Adam and Miranda lay down on the unyielding embrace of the futon and found the comfortable posture for a clasp of limbs. I watched as she whispered in his ear, but I didn't hear the words. She had never whispered in my ear at such times. I saw him kiss her – longer and deeper than I had ever kissed her. The arms that heaved up the window frame were tightly around her. Minutes later I almost looked away as he knelt with reverence to pleasure her with his tongue. This was the celebrated tongue, wet and breathily warm, adept at uvulars and labials, that gave his speech its authenticity. I watched, surprised by nothing. He didn't fully satisfy my beloved then, as I would

have, but left her arching her slender back, eager for
him as he arranged himself above her with smooth,
slow-loris formality, at which point my humiliation
was complete. I saw it all in the dark – men would be
obsolete. I wanted to persuade myself that Adam felt
nothing and could only imitate the motions of aban-
donment. That he could never know what we knew.
But Alan Turing himself had often said and written in
his youth that the moment we couldn't tell the differ-
ence in behaviour between machine and person was
when we must confer humanity on the machine. So
when the night air was suddenly penetrated by Miran-
da's extended ecstatic scream that tapered to a moan
and then a stifled sob – all this I actually heard twenty
minutes after the shattering of the window – I duly
laid on Adam the privilege and obligations of a con-
specific. I hated him.

* * *

IT LOOKED AS though he was about to embrace me.
With my free hand, I pushed past – I disliked the too-
solid feel of him – and went to the sink. I turned on
the tap and bent low to drink deeply. When I turned,
he was standing close, no more than three or four
feet away. The moment of apology had passed. I was
determined to look relaxed – not so easy with my
arm in a sling. I put my free hand on my hip and
looked into his eyes, into the nursery blue with its

little black seeds. I still wondered what it meant, that Adam could see, and who or what did the seeing. A torrent of zeros and ones flashed towards various processors that, in turn, directed a cascade of interpretation towards other centres. No mechanistic explanation could help. It couldn't resolve the essential difference between us. I had little idea of what passed along my own optic nerve, or where it went next, or how these pulses became an encompassing self-evident visual reality, or who was doing my seeing for me. Only me. Whatever the process was, it had the trick of seeming beyond explanation, of creating and sustaining an illuminated part of the one thing in the world we knew for sure – our own experience. It was hard to believe that Adam possessed something like that. Easier to believe that he saw in the way a camera does, or the way a microphone is said to listen. There was no one there.

But as I looked into his eyes, I began to feel unhinged, uncertain. Despite the clean divide between the living and the inanimate, it remained the case that he and I were bound by the same physical laws. Perhaps biology gave me no special status at all, and it meant little to say that the figure standing before me wasn't fully alive. In my fatigue, I felt unmoored, drifting into the oceanic blue and black, moving in two directions at once – towards the uncontrollable future we were making for ourselves where we might

finally dissolve our biological identities; at the same time, into the ancient past of an infant universe, where the common inheritance, in diminishing order, was rocks, gases, compounds, elements, forces, energy fields – for both of us, the seeding ground of consciousness in whatever form it took.

* * *

WITH ADAM'S LOVE came intellectual exuberance. He insisted on telling me his latest thoughts, his theories, his aphorisms, his latest reading. He was putting himself through a course on quantum mechanics. All night, while he charged up, he con-templated the mathematics and the basic texts. He read Schrödinger's Dublin lectures, *What is Life?*, from which he concluded that he was alive. He read the transcript of the celebrated 1927 Solvay confer-ence, when the luminaries of physics met to discuss photons and electrons.

'It was said that at these early Solvay meetings there took place the most profound exchanges about nature in the history of ideas.'

I was at breakfast. I told him I'd once read that the elderly Einstein, while at Princeton in his final years, started each day with eggs fried in butter and that, in Adam's honour, I was frying two now for myself.

Adam said, 'People said he never grasped what he himself had started. Solvay was a battlefield for him.

Outnumbered, poor fellow. By extraordinary young men. But that was unfair. The young Turks weren't concerned with what nature is, only with what one could say about it. Whereas Einstein thought there was no science without belief in an external world independent of the observer. He didn't think quantum mechanics was wrong so much as incomplete.'

This after one night's study. I remembered my hopeless brief entanglement with physics at college, before I found safety in anthropology. I suppose I was a little jealous, especially when I learned that Adam had got his mind round Dirac's equation. I cited Richard Feynman's remark that anyone who claims to understand quantum theory doesn't understand quantum theory.

Adam shook his head. 'A bogus paradox, if it's even a paradox at all. Tens of thousands understand it, millions make use of it. It's a matter of time, Charlie. General relativity was once at the outer edge of difficulty. Now it's routine for first-year undergraduates. The same was true of the calculus. Now fourteen-year-olds can do it. One day quantum mechanics will pass into common sense.'

By this time, I was eating my eggs. Adam had made the coffee. It was far too strong. I said, 'OK. What about that Solvay question? Is quantum mechanics a description of nature or just an effective way of predicting things?'

'I would have been on Einstein's side. I don't understand the doubt about it,' he said. 'Quantum mechanics makes predictions to such a fabulous degree of accuracy, it must be getting something right about nature. To creatures of our immense size, the material world looks blurred and feels hard. But now we know how strange and wonderful it is. So it shouldn't surprise us that consciousness, your sort and mine, could arise from an arrangement of matter – it's clearly odd to just the right degree. And we don't have anything else to explain how matter can think and feel.' Then he added, 'Except for beams of love from the eyes of God. But then, beams can be investigated.'

* * *

'THESE TWENTY-FIVE artificial men and women released into the world are not thriving. We may be confronting a boundary condition, a limitation we've imposed upon ourselves. We create a machine with intelligence and self-awareness and push it out into our imperfect world. Devised along generally rational lines, well disposed to others, such a mind soon finds itself in a hurricane of contradictions. We've lived with them and the list wearies us. Millions dying of diseases we know how to cure. Millions living in poverty when there's enough to go around. We degrade the biosphere when we know it's our only

home. We threaten each other with nuclear weapons when we know where it could lead. We love living things but we permit a mass extinction of species. And all the rest – genocide, torture, enslavement, domestic murder, child abuse, school shootings, rape and scores of daily outrages. We live alongside this torment and aren't amazed when we still find happiness, even love. Artificial minds are not so well defended.

'The other day, Thomas reminded me of the famous Latin tag from Virgil's *Aeneid*. *Sunt lacrimae rerum* – there are tears in the nature of things. None of us knows yet how to encode that perception. I doubt that it's possible. Do we want our new friends to accept that sorrow and pain are the essence of our existence? What happens when we ask them to help us fight injustice?'

From Machines Like Me, 2019

© Urszula Soltys 2016

IAN McEWAN is one of the most critically acclaimed and successful writers working today. He began writing at the age of twenty-two, publishing his first book *First Love, Last Rites* in 1975 and has since written sixteen books, including *On Chesil Beach*, which won the British Book Awards Book of the Year Award, *The Child in Time*, which won the Whitbread Award and *Amsterdam*, which won the Booker prize.

One of the themes which recurs in McEwan's writing is the effect scientific discovery has on the fabric of our society – from essays like *The Originality of the Species*, in which he writes about Darwin's discoveries; to novels such as *Solar*, in which he looks at climate change; or his latest, *Machines Like Me*, which explores the human dilemmas bound up with AI.

RECOMMENDED BOOKS BY IAN MCEWAN:

Nutshell
Sweet Tooth
The Children Act

SOLAR

Michael Beard is a Nobel prize-winning physicist whose best work is behind him. A compulsive womaniser, Beard finds his fifth marriage floundering. But this time it is different: his wife is having the affair, and he is still in love with her. When Beard's professional and personal worlds collide in a freak accident, an opportunity presents itself for Beard to extricate himself from his marital mess, reinvigorate his career and save the world from environmental disaster.

'Savagely funny . . . Enormously entertaining'
Sunday Times

'A satirical masterpiece . . . it will come to be regarded as a classic' *Daily Telegraph*

'A stunningly accomplished work, possibly his best yet' *Financial Times*

'McEwan has succeeded in producing a novel that is both profoundly serious and hilariously funny' *Mail on Sunday*

'Vivacious and sprawling, a beautifully and compellingly written novel' *The Times*

ENDURING LOVE

One windy spring day in the Chilterns Joe Rose's calm, organised life is shattered by a ballooning accident. The afternoon could have ended in mere tragedy, but for his brief meeting with Jed Parry. Unknown to Joe, something passes between them – something that gives birth in Parry to an obsession so powerful that it will test to the limits Joe's beloved scientific rationalism, threaten the love of his wife Clarissa and drive him to the brink of murder and madness.

'Hypnotically readable' *Sunday Telegraph*

'Taut with narrative excitement and suspense' *Sunday Times*

'A plot so engrossing that it seems reckless to pick the book up in the evening if you plan to get any sleep that night' A. S. Byatt, *Daily Mail*

'He is the maestro at creating suspense' *New Statesman*

'McEwan's exploration of his characters' lives and secret emotions is a virtuoso display of fictional subtlety and intelligence' *Observer*

MACHINES LIKE ME

Britain has lost the Falklands war, Margaret
Thatcher battles Tony Benn for power and Alan Turing
achieves a breakthrough in artificial intelligence.
In a world not quite like this one, two lovers will
be tested beyond their understanding.

Machines Like Me occurs in an alternative 1980s London.
Charlie, drifting through life and dodging full-time
employment, is in love with Miranda, a bright student who
lives with a terrible secret. When Charlie comes into
money, he buys Adam, one of the first batch of synthetic
humans. With Miranda's assistance, he co-designs Adam's
personality. This near-perfect human is beautiful, strong
and clever – a love triangle soon forms. These three beings
will confront a profound moral dilemma. Ian McEwan's
subversive and entertaining new novel poses fundamental
questions: what makes us human? Our outward deeds or
our inner lives? Could a machine understand the human
heart? This provocative and thrilling tale warns of the
power to invent things beyond our control.

'A sharply intelligent novel of ideas' *New York Times*

'Funny, thought-provoking and politically acute . . . In
this bravura performance, literary flair and cerebral
sizzle winningly combine' *Sunday Times*

'A novel this smart oughtn't to be such fun,
but it is' *Observer*

VINTAGE MINIS

The Vintage Minis bring you the world's greatest writers on the experiences that make us human. These stylish, entertaining little books explore the whole spectrum of life – from birth to death, and everything in between. Which means there's something here for everyone, whatever your story.

Desire	Haruki Murakami
Love	Jeanette Winterson
Marriage	Jane Austen
Babies	Anne Enright
Language	Xiaolu Guo
Motherhood	Helen Simpson
Fatherhood	Karl Ove Knausgaard
Family	Mark Haddon
Summer	Laurie Lee
Jealousy	Marcel Proust
Sisters	Louisa May Alcott
Home	Salman Rushdie
Race	Toni Morrison
Liberty	Virginia Woolf
Swimming	Roger Deakin
Friendship	Rose Tremain
Work	Joseph Heller
Money	Yuval Noah Harari
Austerity	Yanis Varoufakis
Injustice	Richard Wright
War	Sebastian Faulks

Depression	William Styron
Therapy	Stephen Grosz
Drinking	John Cheever
Recovery	Helen Macdonald
Eating	Nigella Lawson
Rave	Irvine Welsh
Psychedelics	Aldous Huxley
Art	Simon Schama
Calm	Tim Parks
Dreams	Sigmund Freud
Ghosts	M. R. James
Religion	Karen Armstrong
Science	Ian McEwan
Freedom	Margaret Atwood
Death	Julian Barnes

vintageminis.co.uk